drawing 365

NORTH LIGHT BOOKS
CINCINNATI, OHIO
www.artistsnetwork.com

ISBN-13: 978-1-4403-3658-4

fw
a content + ecommerce company

Other fine North Light Books are available from your
favorite bookstore, art supply store or online supplier.
Visit our website at www.fwmedia.com.

18 17 16 15 14 5 4 3 2 1

Commissioning Editor: Jacqueline Ford
Assistant Editor: Tamsin Richardson
Layout: Emily Portnoi and Michelle Rowlandson
Cover Design: Hannah Bailey

Cover Image Credits
Front cover (clockwise from top left): Rush Hour
Crowds and Trains Moving Inside Canary Wharf,
London, England by Jeanette Barnes; Afro XX by
Adebanji Alade; Lippiano, Umbria, Italy by Mat Barber
Kennedy; Pick of the Litter by Katherine Tyrrell; Small
Spaniel by Gayle Mason; Tanah Lot, Bali, Indonesia
by Katherine Tyrrell; A Child by Julie Douglas;
Sunflowers by Katherine Tyrrell.

Spine:
Pick of the Litter by Katherine Tyrrell

Back cover (left to right):
Coffee Cans in the Conservatory by Felicity House;
Audrey 2 by John Smolko; Early Morning in January
(Canary Wharf series) by Katherine Tyrrell.

drawing 365

Tips & Techniques to Build Your Confidence & Skills

KATHERINE TYRRELL

NORTH LIGHT BOOKS
CINCINNATI, OHIO
www.artistsnetwork.com

CONTENTS

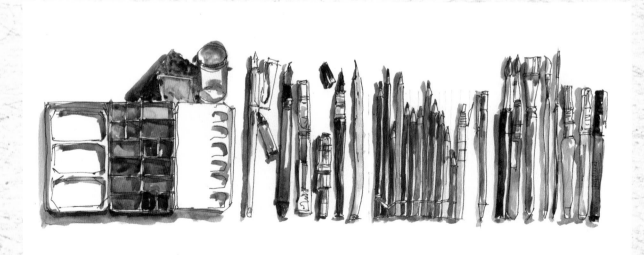

Sketching Media by Liz Steel (Pen, ink and watercolor)

INTRODUCTION
BUILD YOUR CONFIDENCE

USING THIS BOOK

When I started to write this book, I was minded to create the type of book I wish I'd had when I first started to draw. Over time you learn so much—so many tips, so many techniques—and it's always good to share!

I've been reminded while writing of all the things that seem difficult to start with, many of which get easier with practice. You don't need to read this book from front to back; however, I do recommend you complete this section before deciding what to read next.

WHAT IS DRAWING?

Freehand drawing is an activity that is enjoyed by people of all ages. It's a natural, almost instinctive activity, but while it's not unusual to see children and young people drawing, adults tend to give it up. Yet many look back on it with fondness, as something they enjoyed doing and want to be able to revisit.

"Do not fail, as you go on, to draw something every day, for no matter how little it is, it will be well worthwhile, and it will do you a world of good."
—Cennino Cennini (c.1370–c.1440)

Courtyard Outside Burlington House, London, England by Katherine Tyrrell (Pen, ink and colored pencil)

WHAT DO YOU THINK OF WHEN YOU THINK OF A DRAWING

Drawings can be about a number of things. They can be observational, acting as a record of the things we see, and perhaps done in a cool and analytical style. They can also be imaginative, reinterpreting things and even presenting them as we think they should look. Lastly, they can draw on our emotions, reflecting the way we feel about a particular subject.

There are various approaches we can take when drawing. For example, a realistic style would typically involve presenting an accurate and faithful record of our observations, whereas an impressionistic approach might offer a more fluid, instant impression of a moment in time. Expressionistic drawings, which present a subjective, sometimes emotional, response to objects or events.

Drawing is, in fact, a basic foundation for all visual art, and this book touches on every aspect, from specific skills and techniques to practical tips.

Life Drawing by Katherine Tyrrell (Pen and ink)

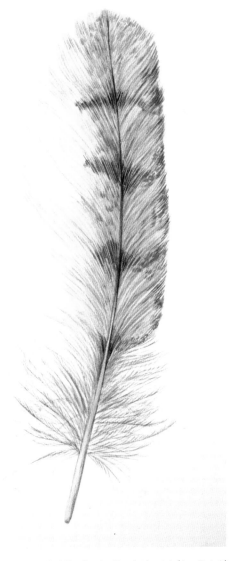

Barn Owl Feather by Sarah Morrish (Acrylic ink)

Chapter 1 introduces some of the more important concepts and skills associated with drawing, and Chapter 2 applies to these different subjects, providing further practical tips to help you develop.

All the techniques and all the subject matter in this book can be drawn and sketched using ANY drawing media. You may be surprised what can be used for drawing. You can find out more about different types of drawing media and related tools and equipment in Chapter 3. You'll also see them demonstrated in the images throughout the book.

WHY DO WE DRAW?

Drawing and sketching happens for different reasons and in different ways. Drawings might function as:

- A record of something you've seen or somewhere you've been.
- Revision and refinement of your skills in drawing and mark-making.
- Part of a study of art history, perhaps involving copying an artwork by a famous artist from the past.
- An aid to understanding, for example, how something is constructed or works.
- Part of a creative process, a way of exploring an idea.
- A means of emotional release, through the expression of feelings.
- A quick drawing in a limited time period.
- A preliminary study for another type of art.
- An outline or template for another painting.
- A piece of fine art to be displayed in an exhibition, bought by collectors and/or kept by a museum.
- Graphic art for use in a commercial context, such as an advertisement.
- A technical drawing, such as an architect's drawing.

For me personally, drawing and sketching are my two big passions. I drew a lot as a child and while at school. I came back to drawing as an adult after a long time dedicated to higher education, professional studies and getting a career off the ground.

I found drawing and sketching to be invaluable in helping me achieve a work/life balance—giving me "time-out" and respite from a busy, analytical, number-oriented worklife. I've not stopped drawing since.

THE BENEFITS OF DRAWING

Life sometimes gets in the way of drawing. However, once we fall in love with drawing again and embrace it as we did when we were children, it can become a lifelong and richly rewarding activity.

The rewards are numerous, and the kinds of benefits drawing can bring are as diverse as the kinds of people who do it. It is a great creative outlet for people, regardless of their age (it is a really great activity for when you retire), and is a wonderful way to stimulate and engage the brain. For many people, myself included, drawing is an effective and meaningful method of recording holidays and longer travels. The view you draw stays with you forever!

Drawing can also be a great way to relax and escape the stresses and strains of everyday life, whether at work or at home, and it is so versatile: You can sketch wherever you are, at home or out and about, meaning you will never be short of something to do, and it is satisfying! What better way is there of realizing more of your potential, and of being proud of an achievement in a context other than work? As we progress and become better at drawing, so we enjoy greater confidence—in what we can do and who we are. And, who knows, maybe one day it could become a whole new career?

*Opposite: **Spring Flowers in Vollissos, Greece** by Katherine Tyrrell (Pastel); Drawn from observation on a warm morning in May while sat next to a roadside verge in Greece. Below: **St. James Park, London, England** by Katherine Tyrrell (Colored pencil); This is a crop of an even wider panoramic sketch.*

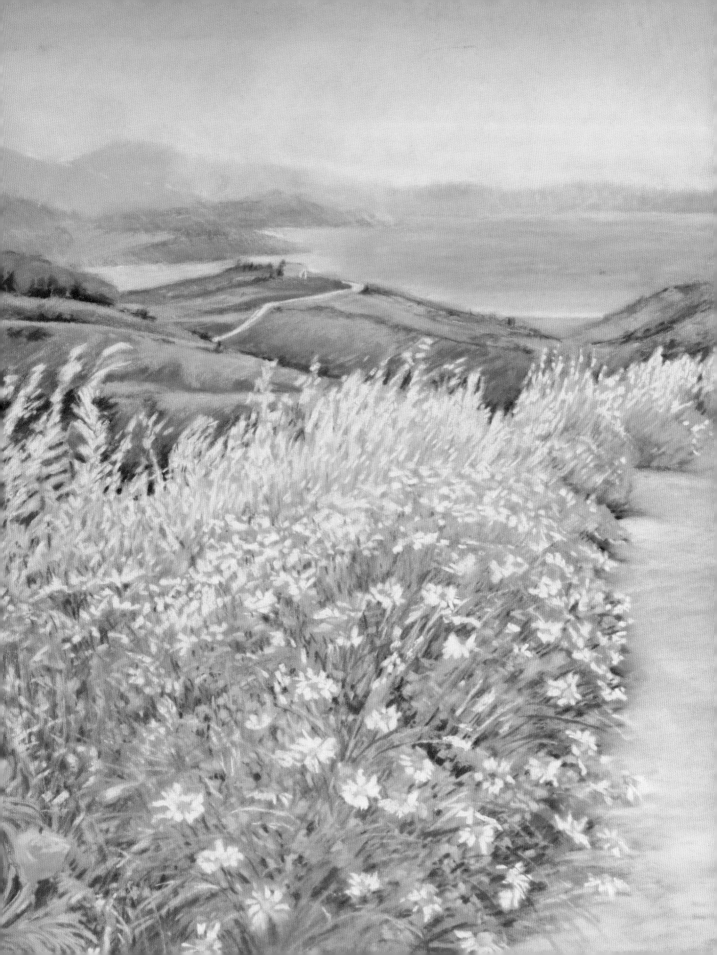

ABOUT THIS BOOK

This book has been conceived and written for people who already have an interest in drawing and want to know more.

It is for those who have drawing skills, but maybe haven't used them for a long time, and who want to stop copying photos and start drawing from observation and in new locations.

It is also intended for artists who have been drawing for some time and are now looking to expand their horizons. With this audience in mind, the tips in this book vary from basic to advanced and offer plenty of practical guidance.

A Compendium of People by Lis Watkins
(Pen, ink and watercolor)

Flowers for Shabat by Reuven Dattner
(Pen and watercolor)

"You can't do sketches enough.
Sketch everything and keep
your curiosity fresh."
—John Singer Sargent (1856–1925)

Feel free to dip into the book whenever you like, and at whichever point you choose. You may find you have more success with some tips after you start to draw and sketch on a regular basis and your skills have developed more. The book also features work in a mix of styles, from traditional to contemporary. Some you may already be familiar with, others will introduce you to new approaches and techniques.

Tips are grouped around themes and offer concise and practical advice to help you develop. There is no right or wrong way to use this book: Choose the tips and techniques you find interesting, in any order that works best for you.

Revisit these techniques and tips as you build up your portfolio of drawings and sketches to see how you are progressing and brush up on specific techniques. The advanced tips may at first seem overly complex, but over time you will find your understanding increasing. It is a good idea to make a note of the tips you have used alongside each drawing so as to have a useful reference for the future. Explore the information and prompts to find out more about drawing and related topics too. If you get stuck with a drawing, revisit this book and see if there's something that gives you another perspective and helps solve your problem.

Norfolk Drawing Class by Walt Taylor (Digital)

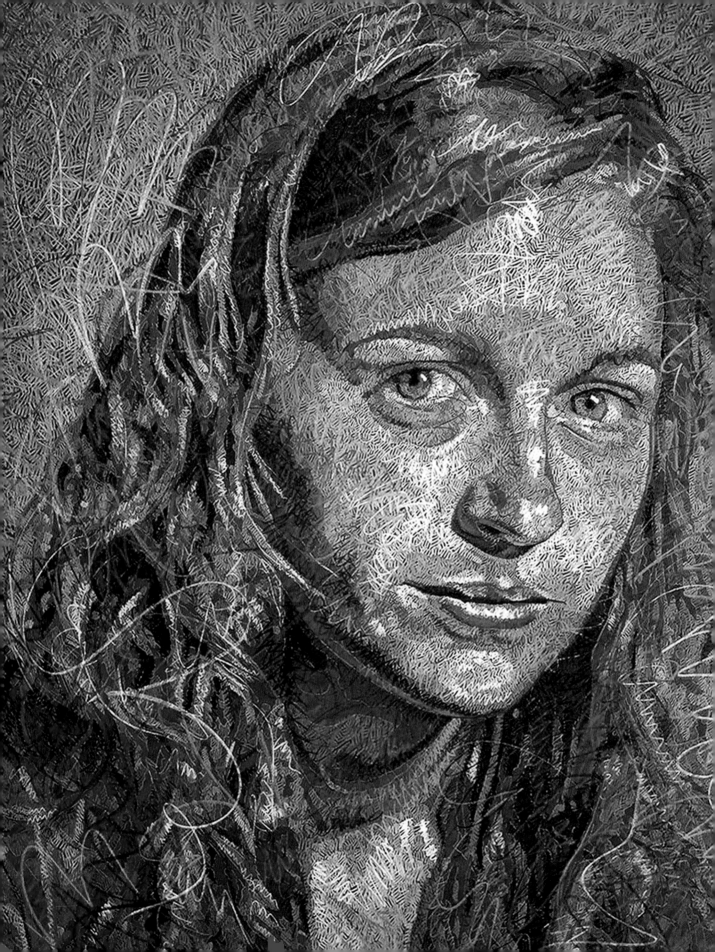

1. DRAWING BASICS

This chapter looks at ways you can become more confident about your drawing, whether you are a beginner or you're looking to improve skills you already have. Here, the focus is on acquiring:

- New habits, such as learning how to see and draw.

- The vocabulary and language of drawing.

- Different ways of designing and drawing pictures.

- Ways in which to develop your art.

Audrey 2 by John Smolko
(Colored pencil)

LEARN TEN NEW HABITS

1

Draw frequently so that drawing becomes instinctive

Drawing involves the brain as well as the hand. It requires you to make decisions and put thought into your work. Drawing every day, or as often as you can, is the very best way to improve your drawing ability. Once you have learned how to draw, practice is the key to improvement, as with any other activity, whether it's playing the piano or driving a car. The more you draw, the more instinctive the process will become, and in time you will find yourself making decisions about a drawing's development on an almost subconscious level.

Cosmo by Katherine Tyrrell (Top image: Graphite pencil; bottom image: Digital drawing); Two 30-second sketches of my cat Cosmo, who I often use for a quick visual workout. The second digital image was completed in one continuous line.

Quick Contour Sketch by Katherine Tyrrell (Pen and ink); Drawn in three minutes after two years of weekly classes.

2

Start with a five-minute drawing

Drawing from observation—rather than from photos—is a skill that takes time and practice to develop. You can practice by doing a quick five-minute drawing every day. It is a great exercise for all artists to do, regardless of their circumstances—everybody has five minutes free each day, and it doesn't have to be a masterpiece. You don't need to show anyone.

Once you've done this for a while, see if you can find time to expand this to ten minutes.

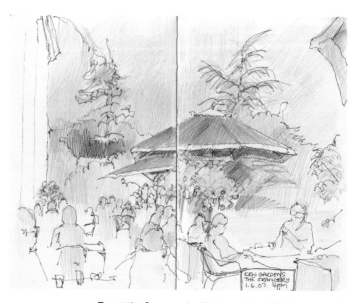

Tea at the Orangery by Katherine Tyrrell (Colored pencil); Just time for a ten-minute sketch over a cup of tea.

3

Carry a small sketchbook with you all the time

Keep making lots of quick drawings, wherever you happen to be. The easiest way to do this is to start carrying a sketchbook and something to draw with. You'll find you draw much more without ever having to make time.

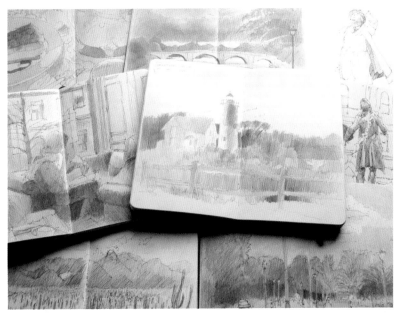

A spread of my small sketchbooks. I usually use one measuring 8 x 5in. which allows for an 8 x 10in. double-page spread.

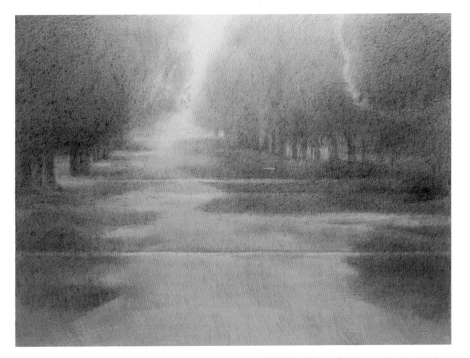

Syon Vista Summer by Katherine Tyrrell (Colored pencil); I'm now starting to draw in less detail and with more color. This drawing was developed following a sketching trip to one of my favorite places, Kew Gardens in London, England.

4

Indulge yourself! Give yourself the space and time to draw what you enjoy

If you draw what you enjoy, you'll always find time for drawing. Make time for longer sessions dedicated to drawing what you enjoy the most.

5

Compare your drawing with past work and not other people's work

Drawing is not a contest, and there isn't one correct way of drawing. Your technique will develop over time; the more you work at it, the better it will become. Keep your sketchbook and resist the temptation to tear out the "failures." As you look back over the work you did in the past you'll be amazed by the progress you've made.

Some of my sketches from Travels With a Sketchbook.

6

Remember: Nobody's perfect

Try to do your best, but remember: Nobody ever produces perfect drawings all the time. You might be very surprised if you took a look at the day-to-day drawings of many artists. Nobody's perfect.

7

The feel-good factor

Feel good when you draw. Losing yourself in a drawing is akin to meditation and provides relief from the stress of everyday life. Drawing when you feel good often means your drawing becomes fluid and effective too.

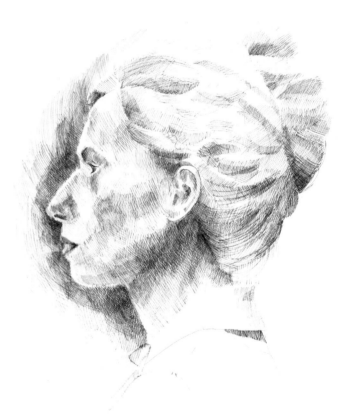

8

Achieve mastery of a medium or technique

Skills and competence do not arrive as soon as you start. Listening, observing, learning, practicing and doing are the five activities that help you to develop mastery. Developing your mastery of a chosen medium or technique will make a big difference to your confidence in drawing.

Female Profile by Katherine Tyrrell *(Pen and ink); My drawings of people improved after I made myself draw heads in pen and ink.*

9

Drawing is a journey

There's always something new to draw or learn. Your journey with drawing may never end, so it's important to enjoy the scenery en route. We all take our own path to get to the place we want to be, and it always takes time to get there. Record your progress by keeping a journal or a blog.

10

Start drawing at home... and then start traveling

You can start at home but don't be afraid of moving on to new places. Who knows—a little further down the line you may decide to travel the world with your sketchbook.

Oaks and Light Snow by Sarah Gillespie (Charcoal); Delicate traceries of twigs and tracks in the snow reveal the subtlety of charcoal as a medium.

LEARN HOW TO SEE

Learning how to draw might also be classified as learning how to see.
Once you've learned how to see and draw, looking becomes very pleasurable.
You can enjoy the world around you in a much more intense way.

*Not Quite White by Katherine Tyrrell (Colored pencil); I love the abstract shapes
and patterns associated with macro perspectives on plants and flowers.*

11

Draw what interests you

Your vision is unique to you. Take the time to look around and identify what interests YOU! Sit a number of artists down in front of the same subject and they will all see it differently and draw it differently. This means there's no need to worry about whether or not your drawing looks like anybody else's.

12

Drawing is about observation

People new to drawing sometimes make the mistake of starting to draw too quickly. Explore with your eyes and study all the lines, shapes and shading before you start. As you draw, try following this simple process:

1. Observe and draw.

2. Compare what you've drawn to what you saw and note what you've learned.

3. Repeat the process.

If you find you're spending too much time staring at your drawing, make a point of looking up more and then drawing without looking at your paper (see opposite page).

13

Avoid being a human photocopier

Cameras cannot match your eyes' ability to see reality. Your eyes will help you to produce a better drawing of what's real and to create the best drawing you can. Before working with photographs (see pages 50–51), develop your drawing skills and understand the limitations of photographs, and how you can address these limitations.

"Most people never learn to see well enough to draw."

—Betty Edwards (b.1926)

In the Bath by Laura Frankstone (Pencil); A blind contour drawing, completed without the artist looking at the page.

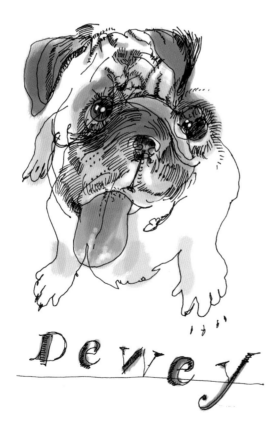

Dewey by Walt Taylor (Pen and ink); A blind contour sketch of a pug with digital color added later.

14

Develop your visual memory

Develop your capacity to remember visual information between observing it and recording it. This will really help you to draw well and accurately.

HOW TO DRAW WITHOUT LOOKING AT YOUR PAPER

Blind contour drawing is a traditional activity aimed at developing visual memory and hand–eye coordination. Simply put, it consists of drawing without looking at the paper:

1. Study your subject for a minimum of five minutes.

2. Mentally draw the contour of the subject with your eyes.

3. Decide where on the paper you will start and how you will progress.

4. Place your pencil on the paper at the starting point.

5. Now draw without looking at the paper.

6. If you get stuck, look down and reposition your pencil on the paper before continuing.

7. Review your drawing.

Try drawing different objects to develop hand–eye coordination.

15

Look at your subject more than your paper

People who draw well tend to spend a lot of time looking at the subject. But people who don't take the time to observe the subject typically spend more time looking at what's happening on the paper.

16

Distinguish between dominant and subordinate details

When you look at your subject:

- Identify which details are dominant.

- Identify what's important and what makes you want to draw.

- Decide which aspects are unimportant and which you can afford to lose.

17

Look for the lights and darks

Variations in tone create areas of light and dark and give form to flat shapes, making a picture come to life. You can't portray a light pattern if you can't see it.

18

Life doesn't come with edges

While photographs provide a ready-made frame for your own drawing, working from observation requires you to define the edges of the drawing yourself. Use a viewfinder to help you decide how to frame what you're drawing (see pages 54–55). You can find them in art stores, app stores, on your camera, or you can make your own (see right).

EXERCISE: MAKE A VIEWFINDER

Using dark-colored stiff card, you can make a viewfinder by following these simple steps:

1. Cut two identical rectangles from the card, both with a window at the center (ratio 3:4).

2. At the top of both, create a rounded recess.

3. Tape the rectangles together along three edges to create a sleeve.

4. Cut another marginally smaller rectangle (without a window or recess) and insert it into the sleeve. It should move in and out easily.

5. Move the insert to reveal a viewfinder.

6. See how many different ways you can frame your subject matter before you start to sketch or draw.

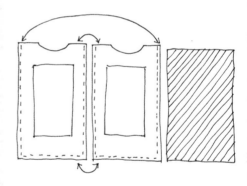

19

Draw what you see, not what you think you see

It's very common to find people drawing their idea of what something looks like rather than what they can actually see. Forget about what you think your subject should look like and draw what it actually looks like. Pay attention to shapes (see pages 28–29), spaces (see pages 30–31) and edges (see pages 34–37). Life drawing (see pages 82–83) provides excellent training in the art of learning how to see.

20

Review what you've drawn

Here are some effective techniques that will help you see your own drawings with fresh eyes:

* **Put your drawing at a distance:** This helps identify a center of interest (see pages 56–57) and strong design.

* **Turn the drawing upside down:** Stand back and see how it "reads" as an image. This can often highlight issues relating to values and contrast.

* **Look at it in a mirror:** Reversing the image causes problem areas to jump out at you.

* **Take a break:** Put it away and come back to it after a break.

DIFFERENT WAYS OF CROPPING AN IMAGE

Drawing frames for sketches on your paper will make you think more about how you can fill them.

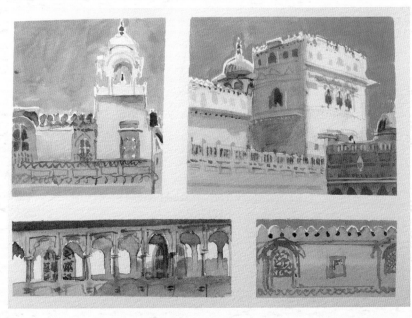

Sketches of Bikaneer Palace, India by Felicity House (Watercolor)

What I See From Where I'm Sitting #7 by Walt Taylor (Pen and ink); Objects viewed from the same spot in a room.

HOW TO DRAW WHAT WE SEE

This section deals with the skills and elements of the language of drawing.

Learn the language of drawing to describe and draw what you see

There's a new vocabulary to learn, plus principles or new rules of grammar.

ELEMENTS OF DRAWING

Everything we look at has different elements which can be described by how we draw. You can apply any of these elements to any drawing, whether it's of a person in pen and ink, or a landscape in charcoal.

The elements of every visual image include:

- Shape and form
- Space
- Lines and edges
- Values
- Color/monochrome
- Texture

The basic skills involved in drawing are:

- Observation
- Mark-making
- Measurement (proportion)

Areas for development are:

- Perspective
- Working with photographs

Note: Explanations of words that are new to you can be found in the Glossary on page 172.

Drawing a Head by Katherine Tyrrell (Pen and ink)

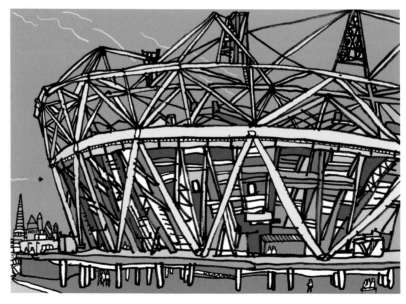

London Olympic Stadium, England by James Hobbs (Marker pen with digital color)

DIFFERENT WAYS OF COMBINING ELEMENTS WHEN DRAWING

Subtle Grandeur by Loriann Signori (Pastel over watercolor)

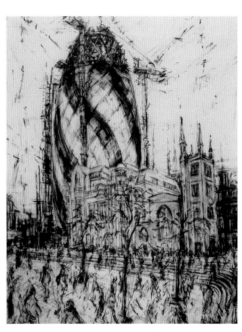

The Gherkin, St. Mary Axe in London, England by Jeanette Barnes (Charcoal)

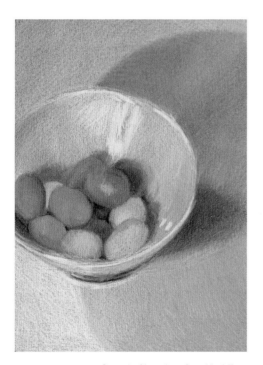

Organic Chocolate Speckled Eggs by Katherine Tyrrell (Colored pencil)

Walk in Progress: Towpath by Chrys Allen (Mixed media)

MARK-MAKING

One of the first steps in drawing involves learning how to make different types of marks, and how these marks represent different ways of conveying what you see.

EXERCISE: VARY MARK-MAKING AND MEDIA

You need to experience this, not just read about it. Experiment with mark-making and different media:

1. Choose a medium (such as graphite) and a surface to work on (such as paper).

2. Draw ten or more boxes and make different marks in each box.

3. Repeat the process with different media and/or supports. Explore how each media responds to the different marks and see how many you can make.

4. Identify which marks you like using and which media work best for you.

Over time, you will develop your own preferences for particular ways of making marks when drawing.

Learn how supports impact media

The type of surface used for drawing (see Tip 324) either inhibits or promotes different types of marks made with different drawing media. For example:

- Lines will be more precise on a smooth finish and more broken on a rough support.

- Pen and ink tends to work better on a smoother surface.

- Scumbling (dragging) works best on an abrasive surface and may be impossible on a smooth surface.

- A watercolor wash needs an absorbent surface.

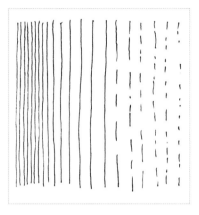

Straight and intermittent lines

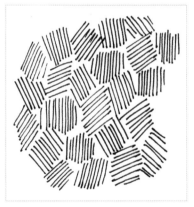

Short strokes/patterns

Develop a mark-making portfolio

Mark-making, like handwriting, is individual to each person. Explore the range of marks you can make using different drawing media.

Loosen up your line

A scribble, by definition, encompasses carelessness, fluidity and randomness. Scribbles can be used in art to achieve an intentionally looser line.

Stippling

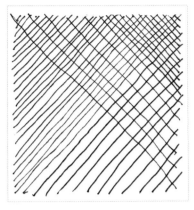

Hatching and crosshatching

Rubbing/blending

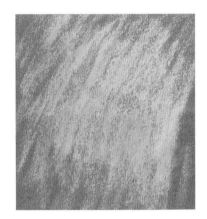

Scumbling

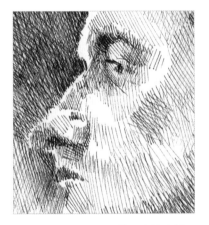

Bracelet hatching

Scribbling

Optical hatching

Indenting

Erasure

Wash

25

MEASURING

Measuring is a basic skill that has to be mastered before relative proportions are correct and a drawing can be made to appear realistic. Most people use a fixed length as a unit of measurement and then compare all other lengths to that. Beware: If you plan on using a photograph as your means of measuring, you risk copying the distortions in measurement introduced by the camera.

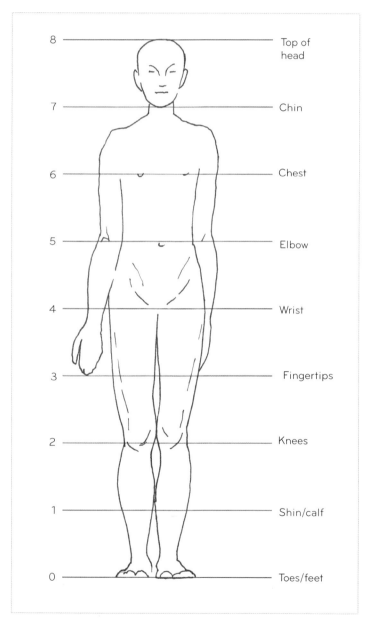

8 — Top of head

7 — Chin

6 — Chest

5 — Elbow

4 — Wrist

3 — Fingertips

2 — Knees

1 — Shin/calf

0 — Toes/feet

The head as a unit of measurement.

25

How to measure using a head

The size of a human head is often used as a basic unit when measuring the size of different parts of a body. Note that the number of heads that add up to the height of a body from top to toe varies depending on gender and age.

26

Find the midpoint of your subject

I use this approach in life class when working out how to fit a full figure onto the paper. Find the center and edges of the main shape of the subject. Work out where the halfway point is relative to the edges of the vertical and horizontal dimensions, and then decide where you want the center of the subject to be on the paper.

27

Practice and "eyeballing"

"Eyeballing" describes the ability to hold a measurement in your head once you have looked at your subject. It depends on the development of visual memory (see Tip 14).

Practice any of these techniques a lot and you'll find that you get much better at:

- Measuring using only your eyes.

- Holding measurements in your memory.

28

How to measure using a pencil

The pencil represents a standard length (one unit). Hold the pencil at the bottom with your arm completely straight and in line with your eye. Avoid raising, lowering or bending your arm as this will affect the length of the pencil in relation to the image. Turn the pencil through 90 degrees to measure the length of horizontal lines.

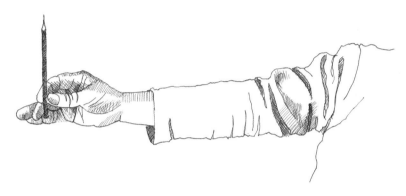

How to use the pencil as a measuring instrument.

29

How to measure using a defined vertical

Australian urban sketcher Liz Steel refers to this as the VIP—the "Very Important Perpendicular." Identify a prominent and fixed vertical or horizontal line, such as the edge of a wall, roofline or the height of a tree to act as the baseline unit of measurement. Use this to measure other verticals or horizontals.

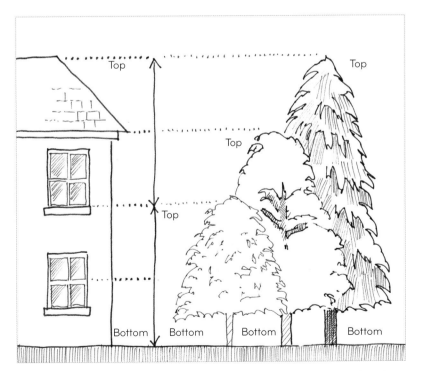

Example of a fixed line within the subject.

SHAPE, FORM AND VOLUME

Shapes of real-world objects are three-dimensional, but drawings can only use two dimensions—height and width.

LEARN ABOUT SHAPE

The following terms are typically used to describe the shape and volume of an object:

- **Shape**: An area defined by length and width. Shapes can be represented by lines, color or shading.

- **Form**: An enclosed space measured in three dimensions—height, width and depth.

- **Volume**: The size of a shape in three dimensions.

- **Density**: This gives a sense of resistance within the shape.

- **Mass**: A three-dimensional solid with a sense of both weight and resistance. It combines volume and density.

Practice drawing very basic shapes

You know what simple shapes look like, but can you draw them? Start by making repeated drawings of simple two-dimensional (2-D) shapes and three-dimensional (3-D) forms until you become comfortable with their geometry. Imagine them as transparent, and include the lines and corners that would otherwise be hidden. You will find circles, ovals and curving elliptical shapes need a lot of practice. This is also a good warm-up exercise.

Draw your subject in the air

This sounds stupid but it works! Learn how to draw your subject before you put pencil to paper. Try tracing the outline of the shape in the air before you start.

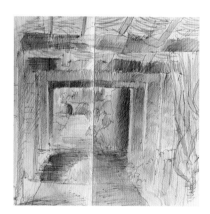

Garden Pergola at Munstead Wood, England; Square/cube: A very stable shape with hard edges.

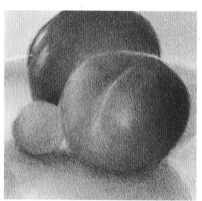

Plums and a Lychee; Circle and semicircle/sphere: A powerful shape that always attracts attention.

*Ancient Yew Trees at Hampton Court Palace, England; Triangle/pyramid: This combines stability with strong diagonal lines that lead the eye. **All three sketches by Katherine Tyrrell** (Colored pencil)*

Begin by blocking in

Give yourself some guidelines when you start to draw. "Blocking in" will help simplify your subject and make it easier to size on your drawing paper:

- First, look for the dominant shapes (such as big, simple geometric shapes) that make up the outline of your subject.

- Now sketch these shapes very lightly.

- Next, check the size, proportions and placement of these shapes.

- And finally, refine lines and add detail only after the big shapes are in place.

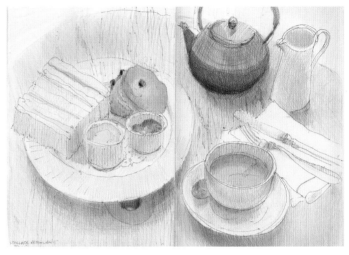

Cream Tea at the Wallace Collection, London, England by Katherine Tyrrell (Colored pencil); I often practice drawing shapes with curves at teatime.

Move from the simple to the particular

Once the basic shapes have been blocked in, you can continue to observe and refine. Start with one part and find the smaller shapes within the big shape. Restate the lines and shapes as you go. There is no need to erase the older lines.

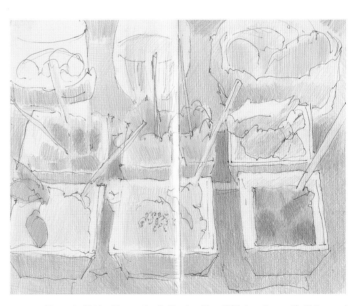

Tapas in Paris, France by Katherine Tyrrell (Colored pencil); This meal was a great opportunity to sketch square shapes from above.

Identify the connected value mass

Shapes do not exist in isolation. Our brain knows that objects are separate and wants to draw what we "know" is there. However, if the light is low or behind the subject, the edges of shapes and their separation from both context and neighboring shapes become very blurred.

Connected shapes—with more or less the same value—can become a much bigger shape.

SPACE AND PROPORTION

Space in a drawing helps to define the objects within and around it. A drawing describes the relationships between objects and space. It uses line, value and color to define these objects and to create the impression of depth, scale and perspective.

LEARN ABOUT SPACE

The following terms can be used to describe space in drawings:

- **Illusion**: A visual representation of a 3-D space in two dimensions.

- **Pictorial space**: The illusion of depth and 3-D space created on a 2-D support.

- **Picture plane**: The 2-D space within the edges of the frame you have set for your drawing.

- **Positive space**: The area filled by an object.

- **Negative space**: The area around and in between the objects.

- **Open/empty space**: This is included in drawings to allow a subject to "breathe" on the paper.

- **Active space**: This describes the space within the image that active subjects can "move" into.

- **Flat space**: A space without curves or any suggestion of depth.

HOW TO DRAW SPACE

1. Draw a chair and the space in and around it to learn about negative shapes.

2. Select a subject to draw, and turn it upside down so it looks less familiar. Draw what you see— use a light color for the positive shape and a dark color for the negative shape.

35

Draw positive space— occupied by the subject

People learning to draw often only draw what is called the 'positive' space. This is the space occupied by the subject (e.g., a vase of flowers, a face, a cat). They tend to leave out or ignore the context in terms of the background.

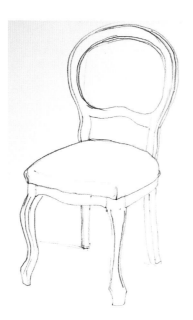

The positive space of a chair.

36

Draw negative space— between and around the subject

If you focus on drawing the negative shapes made in the space in between and around the subject, it becomes much easier to avoid being distracted by thoughts of what shape an object *should* look like.

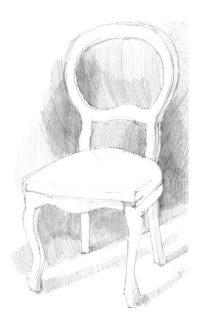

The negative space around a chair.

37

Draw upside down

It's much easier to draw an object if you can see it upside down or from an unfamiliar view. This exercise helps if you have difficulty seeing positive and negative shapes in space, or measuring correctly.

38

Avoid even spaces

Even spaces within a drawing or all the way around the subject should be avoided. Uneven allocation of space works better (see pages 54–57).

39

Draw to scale

Scale is important when drawing in proportion to reality. You might choose to enlarge a subject (if drawing a small part of a flower, for example) or reduce it (if drawing a building). Getting scale and proportion right is important when producing realistic drawings. Ensure, for instance, that doors are large enough for the people in a room. If you deliberately distort scale, this says something about the relative importance of what is distorted.

40

Use a grid system to scale up or down

The simplest method you can use for scaling up is a grid system. It is very simple to learn and remember, and the size of the grid can be adapted to suit the task. (A smaller grid can be used to draw detailed areas.)

HOW TO CREATE A GRID

When scaling an image up or down, there are a few important things to bear in mind:

- Measure with care.

- Make sure that the original picture and the paper you are transferring the image to have the same proportions.

- When creating the grids for the original picture and the blank sheet you are drawing on, make sure that the cells of both have the same proportions.

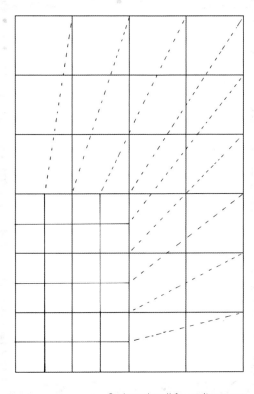

Grids work well for scaling up or down by a precise percentage.

PERSPECTIVE

Improve your confidence with some simple tips on how to introduce perspective into your drawings. There's absolutely no need to get technical unless you want to make very precise drawings of interiors or buildings.

LEARN ABOUT PERSPECTIVE

The following terms can be used to describe perspective in drawings:

- **Eyeline**: A line that runs level with your line of sight.

- **Horizon line**: Where flat ground meets the sky (often the same as the eyeline).

- **Viewpoint/point of view**: An imaginary line between your eye and the object you're looking at. If you sit down, your eyeline and point of view changes.

- **Field of vision**: This includes everything you can see in front of you without turning your head.

- **Binocular vision**: This refers to the fact that each eye has a field of vision that overlaps the other and improves perception of depth. It can be confusing.

- **Vanishing point**: Parallel lines within your field of vision (such as a road going into the distance) converge on the horizon at a single point—and then vanish.

- **Aerial perspective**: Atmosphere alters the appearance of objects in the distance—they appear lighter, and colors become weaker and bluer.

- **Recession**: Objects become smaller as they recede into the distance.

41

You don't have to be precise

Perspective is not always about being precise. Study the drawings of children and artists who often vary both scale and perspective according to what particularly interests them.

42

Overlap shapes to indicate recession

You can indicate depth very simply by placing one object in front of another. This emphasizes their relative positions and makes clear their respective proximity to the viewer. This technique doesn't, however, tell us anything about relative size.

43

Three simple rules for perspective lines

1. Horizontal parallel lines starting below the horizon come up to the eyeline.

2. Lines that start above the horizon come down to the eyeline.

3. Check the angle between the horizontal eyeline and the line going up (or down) and transfer that angle to your drawing.

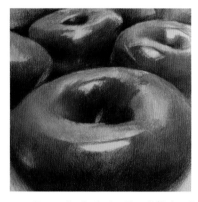

Donuts by Katherine Tyrrell (Colored pencil); The overlapping shapes of chocolate-covered donuts creates recession.

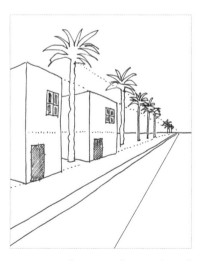

Perspective lines apply to all buildings, people and vegetation.

44

First fix on your horizon

Decide where to place the horizon line on the paper before you start a drawing involving perspective. It can be low (image right) or high (image below), but you need to be clear where it is.

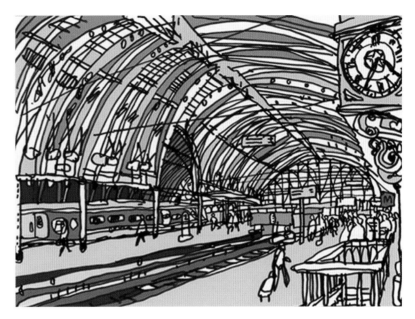

Paddington Station, England by James Hobbs (Marker pen and digital color);
Can you work out where James set the eyeline in this drawing of a station interior?

45

Distance affects all colors and edges

Landscape drawings need to reflect observed phenomena relating to recession. In the distance, edges become fuzzy and definition disappears. Dark colors become lighter, cooler and bluer as they recede into the distance. In contrast, highlights tend to become more subdued and darker. Gradually, everything merges into one color.

EXERCISE: VIEW RECESSION AND AERIAL PERSPECTIVE

When working on landscape drawings, consider the following:

- Observe recession in your environment—what do you notice?

- Look at landscape paintings— what do you notice about colors in the distance?

- Develop color palettes related to recession.

- Develop tint scales (colors mixed using white) to see how well you can grade tints for different tonal values.

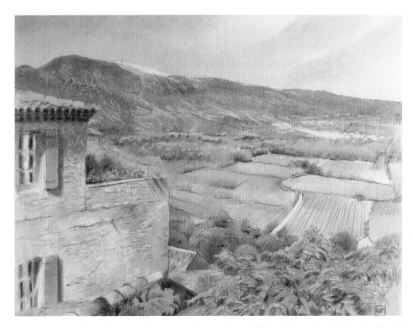

Mont Ventoux, Provence, France From Crillon Le Brave by Katherine Tyrrell
(Colored pencil); Aerial perspective affects the sky as well as the mountains.

LINES AND EDGES

The nature of the line you use in a drawing says something about you
and the subject. A line can be used to describe a space or a form.
It can also describe movement and energy, giving a sense of direction and
perspective. It can have many characteristics. A line can be thick or fine,
straight or curved, clinical or expressive, or controlled or relaxed. These
characteristics should reflect the nature of the subject being depicted.

"A drawing is simply a line going for a walk."
—Paul Klee (1879–1940)

46

Create lines with different characteristics

The act of drawing means you actually feel the character
of the line as your arm and hand apply the medium to the
paper. Energy, pressure and control all affect the nature
of the line, including its width, weight and precision.
The type of drawing medium and support are also
important. For example:

- A fountain pen has a flexible nib that allows greater
 variation of width and weight.

- A technical pen and mechanical pencil both deliver
 a very consistent and precise line.

Thick and thin lines

Lines with direction

Energetic lines

Relaxed lines

*Pen Love by Andrea Joseph (Pen and ink); Andrea employs fine
line crosshatching to achieve dense shading in her drawings.*

47

Develop the control needed to draw a straight line

This is easier said than done. Try drawing a line slowly, and
then try doing it quickly. Draw a vertical line parallel to the
edge of the paper and then do it again.

Rose Garden by Katherine Tyrrell (Pen and ink); Intermittent lines are used to indicate vegetation in this sketch of a rose garden.

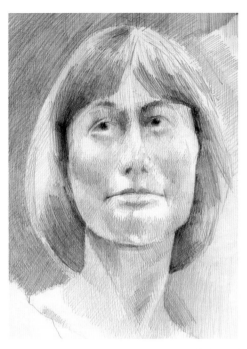

Bracelet Hatching by Katherine Tyrrell (Graphite)

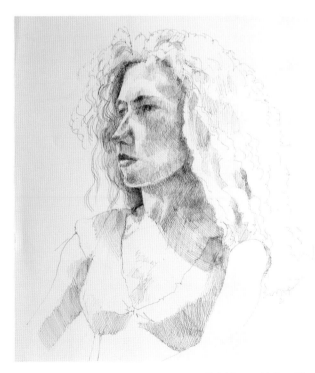

Hatching and Intermittent Lines by Katherine Tyrrell (Indian ink artist pens)

48

Hatching, vertical hatching and crosshatching

Study fine-art drawings by contemporary and Old Masters to see how variations in hatching can be used to create tonal value and suggest the characteristics of surfaces. Bracelet hatching is used a lot in classical drawing to describe the human form.

49

Use intermittent lines

A line does not need to be continuous. Lines that break up are also important. When drawing quickly, my pen dances on the page as I feel my way around the subject. Intermittent lines suggest the outline of things without shouting it out loud.

LEARN ABOUT LINES AND EDGES

Edges tell us about the nature of a subject and how the light falls on it:

- **Outline**: The outside edge of a flat 2-D shape.
- **Contour line**: The shape of a 3-D mass or form.
- **Hard edge**: A defined and precise edge.
- **Soft edge**: A diffuse, vague edge that lacks any definition.

If you start drawing from life instead of photos, you will change from drawing outlines to drawing contours.

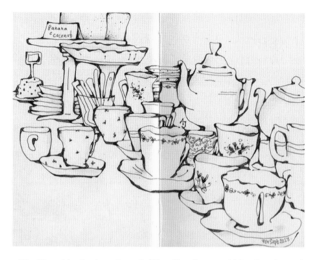

Tea Stand by Andrea Joseph (Blue fine liner and blue brush pen); The hard contour edges are relieved through the variation of line.

50

Hard edges can be hard on the eye

A hard edge can indicate sharp tonal contrast between adjacent shapes due, for example, to a change in light, and they help create emphasis. Be careful, however, as too many hard edges are difficult to look at and can confuse the focus of a drawing.

51

Soft edges smooth away transitions

Soft edges help smooth the transition from one shape or tonal value to the next. They exist where lighting is low, diffuse or behind the subject, and are used where greater subtlety is needed. Take care, though—too many soft edges can confuse a drawing and lead to poorly defined shapes.

Contour Drawing by Katherine Tyrrell (Pen and ink); A simple line drawing of a contour teaches you how to look.

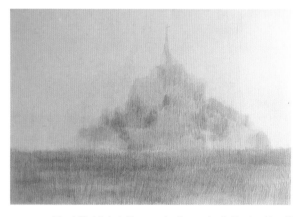

Mont St. Michel, Normandy, France by Katherine Tyrrell (Colored pencil); Soft edges are often needed when using atmospheric perspective.

52

Pretend your pencil is touching the actual contours

Drawing moves up a gear when you literally feel that you are part of the mark you're making. Pretend your pencil is actually touching the object when drawing a contour line. Follow the contour with your eye and slowly draw the same line on your paper.

EXERCISE: BREAK OUT OF YOUR COMFORT ZONE

The No Comfort Zone challenge: Draw a 3-D form with no contour outline.

This exercise is not easy but it really helps build confidence in drawing what you see. Lack of a contour line sharpens focus and increases awareness of the context and contours, and the relationships between the two. Here are the rules:

1. **No erasure allowed**: Draw using pen and ink only.

2. **No contour line allowed**: Draw both positive and negative shapes using tonal mark-making only.

EXERCISE: DRAW A MODEL OR OBJECT USING JUST ONE CONTINUOUS LINE

This is a classic drawing exercise. It makes you think about where you are going to start, where your line will go, and how it will behave:

• Draw the contour of an object without lifting your pen or pencil off the paper.

• Describe both the exterior and interior contours.

• Fill the paper with your drawing.

• Don't lift your pen or pencil off the paper.

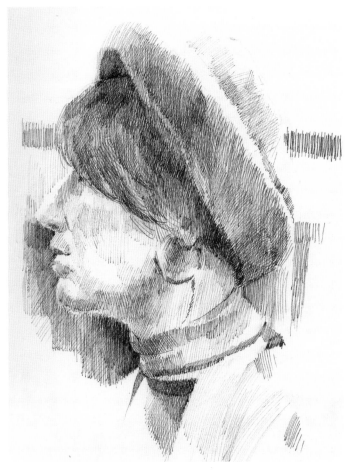

No-Contour Drawing by Katherine Tyrrell (Pen and ink); The shape of the head, hat and neck are entirely defined by hatching shapes.

Catnapping #9 by Katherine Tyrrell (Pen and ink); A contour line, drawn as a single continuous line.

37

LIGHT, SHADE AND TONAL VALUES

Light and dark combine to describe a subject in a pattern of values that range between the lightest highlight and the darkest shadow. Values can be created through a combination of line, shading and color.

LEARN ABOUT LIGHT AND SHADE

The following terms can be used when talking about light and shade:

- **Cast shadow**: A shadow cast onto a surrounding surface by an object blocking the light source.

- **Catchlight**: The intense highlight, or sparkle, in an eye.

- **Chiaroscuro**: A technique that uses intense light and dark to define 3-D objects.

- **Core shadow**: The darkest part of the shadow, farthest away from the light and not affected by reflected light.

- **Form light**: The area of an object exposed to light.

- **Form shadow**: The area of an object not exposed to direct light.

- **Highlight**: The lightest tone; highlights "pop" off the paper when surrounded by darker tones.

- **Reflected light**: Lighter areas within the form shadow, produced by reflections of both light and color.

- **Backlighting**: Light that comes from behind a subject.

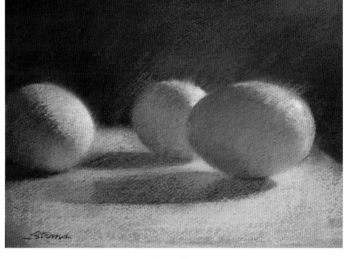

Eggs Trio by Sally Strand (Pastel); Note that virtually no white is used.

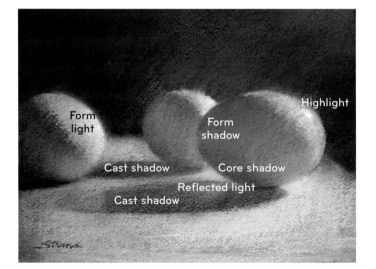

Eggs Trio by Sally Strand (Pastel); Set to grayscale and annotated with the various light and shadow types.

53

Drawing light and shade

Over time, using observation, you will develop an understanding of how to create the impression of light on form. Start by practicing with very simple shapes, such as eggs, and a setup that neutralizes everything except for the light and shade.

54

Assess the lighting

Good light helps reveal both shape and form, while poor lighting can confuse the viewer. The type of light, whether natural or artificial, affects the values and edge quality you see. The direction and intensity of light influences the nature of shadows and how you detect form. The color of the light will naturally affect the colors you see. New kinds of artificial light offer different options for color temperature, from warm (yellow) through neutral to blue (daylight).

HOW TO DEVELOP YOUR TONAL AWARENESS

Each time you look at a drawing or painting, try the following exercises:

- Identify the lightest light and darkest dark.

- Grade all the tones/shades in between.

- Assess the tonal values in a colored shape accurately.

55

Respond to external light

Light and shadows move constantly while drawing outside, and the length of shadows will change as the day progresses. Sketch the value pattern to record the light effect that caught your eye *before* you start to draw. If creating a composite drawing from different sources, ensure all objects relate consistently to a defined light source.

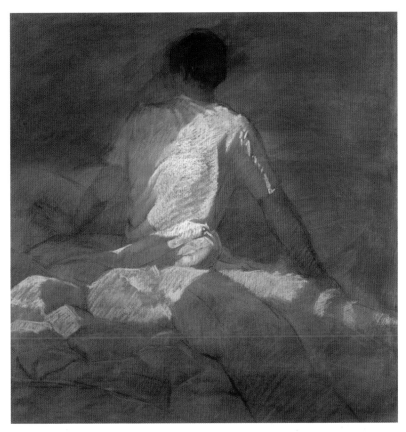

56

Improving the design of your drawings

Drawings that do not use a good range of tonal values often appear very flat and lifeless, whereas images with a strong value pattern tend to catch the eye. Viewed from a distance, all you can see in a drawing is the abstract pattern of light and dark; all the detail is subordinate to the value pattern.

Arising by Sally Strand (Pastel over gouache); From the collection of Greg O'Connor. This image depicts a shaft of early morning light through a nearby window. The figure is Sally's husband getting up in the morning.

IDENTIFYING TONAL VALUES

A tonal pattern is the pattern of light and dark and the shades in between.
These pages outline different approaches to identifying tonal values.

57

How to make a grayscale

A grayscale demonstrates how tonal values of light and shade change between black and white. Use a grayscale to check and compare the tonal value of what you can see and what you have drawn.

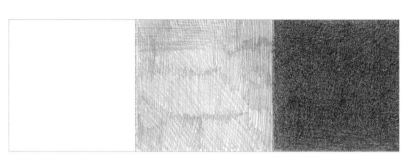

Three-value tonal scale in graphite.

58

Squint to see tone

Squinting is a simple and quick way to see tonal values without using any tools. Use this technique to help develop thumbnail sketches (see page 53).

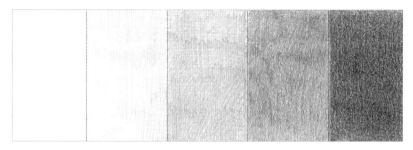

Five-value tonal scale in graphite.

EXERCISE: CREATE TONAL VALUE

Create tonal value scales for three, five and seven tones:

- Use card to create a grid for a range of values.

- Create a hole in the middle of each cell.

- The cell at one end is white, with black at the other end.

- Now gradate the grays in between, using softer graphite for darker values and harder graphite for lighter values.

- Start with the middle value and work back to the extremes.

- Use the hole to view and check values you are not sure about.

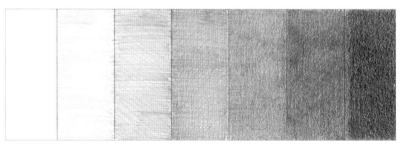

Seven-value tonal scale in graphite.

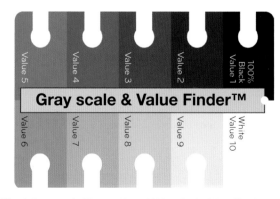

The Colour Wheel Company's "Gray scale and Value Finder" has 10 values.

EXERCISE: SQUINT!

Squint to work out the pattern of the tonal zones, from the darkest to lightest, either by half-closing both eyes or closing one eye completely and half-closing the other. Notice how all the detail disappears, and you can only see light and dark shapes in broad terms.

EXERCISE: USE RED ACETATE TO SEE GRAYSCALE VALUES

A sheet of red acetate will help you to detect tonal difference:

1. Create a window frame from two pieces of hinged card.

2. Insert red acetate to create a red window and then seal with tape.

3. Develop a grayscale on one side to help identify tonal values as seen through the red acetate.

EXERCISE: CHECK YOUR ASSESSMENT OF TONAL VALUES

Using a color photograph as a reference, produce a grayscale drawing, matching the values of the photograph as closely as you can. Now convert the reference photo to a grayscale version using software. Compare it to your own grayscale drawing and see how well you managed to match the values.

To convert a digital image to grayscale using Adobe Photoshop Elements, follow these steps:

1. Open a digital color image in Photoshop Elements.

2. On the top line menu go to Image and then go to Mode.

3. Select Grayscale and click. The image should now be grayscale.

4. Use the Artistic/cutout filter to vary how many shades of gray are in the image.

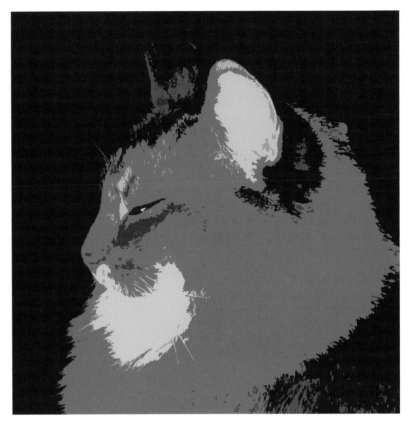

A photo of my cat Cosmo, reduced to three values using software—a dominant dark value, a medium value and a light value.

A grayscale photograph in five values.

A grayscale photograph in three values.

41

Devise different ways of shading

Study the mark-making and media sections (see pages 24–25 and Chapter 3) to better understand the nature of marks and quality of media that can produce very dark and very light tones. Develop a portfolio of different ways you can shade and represent different tonal values. It's better to use a progressively softer pencil, rather than pressure, to produce a change in tone.

EXERCISE: PRODUCE A TONAL BAR

Create a tonal bar using hatching lines. Blend the different tones together so that there are no sharp jumps in tone.

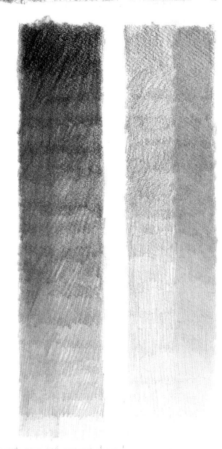

Different ways of shading. The quality of continuous tone produced using dry media and blending tools typically depends on the type of media, support, mark-making and pressure. Top and bottom rows are carbon stick and 6H pencil; two examples of dry media. Pencil columns move from 8B at top to 6F at bottom. Left and right columns represent heavy and light pressure. A paper stump was used to blend half of each sample.

Assess tonal values everyday

Constant practice plus instant feedback help develop competence.

EXERCISE: PRACTICE GRAYSCALE ASSESSMENT

Increase your confidence in reading tonal values with this exercise:

1. Carry a grayscale around with you.
2. Check out ten objects a day.
3. Look at an object and decide which value it is most like.
4. Now hold up your grayscale and check your assessment.
5. Aim to improve the percentage you get right each day.

Get your eyesight checked...

... if you have problems seeing tones. Eye conditions, such as cataracts, can diminish the ability to see both color and tone accurately and can cause blurred vision, so it's advisable to get a checkup if you're having problems.

WORKING IN MONOCHROME

Monochrome refers to a drawing produced using one color. The tonal range is usually represented by black, gray and white, although ßmonochrome drawings can be produced in any one color.

Use monochrome to explore space and form

Removing color from the equation allows much more focus on shape, form and how a subject sits in space and is affected by light. See how much more you learn about how values change across the surface of your subject when you're not distracted by color.

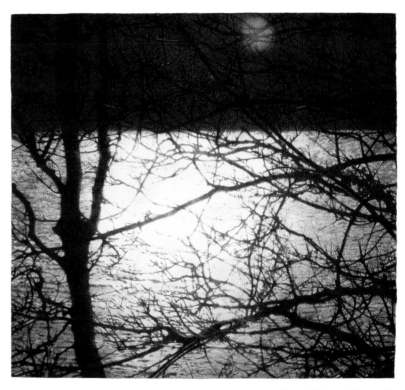

October Moon by Sarah Gillespie (Charcoal)

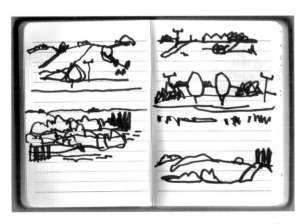

Tiverton Parkway, England: Scenes From a Moving Train by James Hobbs (Marker pens); James habitually uses marker pens when he's not drawing digitally.

Use monochrome media to explore tonal range

Developing a tonal bar requires the use of a monochrome medium. Develop a tonal bar in a color other than gray.

MEDIA FOR DRAWING IN MONOCHROME

The following are media suitable for producing monochrome drawings:

- Graphite
- Carbon pencil
- Compressed charcoal
- Vine charcoal
- Charcoal dust
- Conté/hard pastels
- Black marker pens
- Grayscale marker pens
- One color of ink (any color—use water to produce a range of different tint values).
- Watercolor—one color plus black and white.
- Colored pencil—one hue.

EXERCISE: ASSESS THE IMPACT OF THE SUPPORT

The following will help you to assess the impact of the support:

- Apply the same value of a monochromatic medium to surfaces with different textures.
- Note how the surface of the support becomes more important as a result.
- Try different media on the same surface and decide which you think is the darkest, the lightest, and the most interesting. (There is no right answer.)

Male Torso by Liz Floyd (Charcoal)

The impact of texture on monochrome

The texture of the support has a major influence on the type and impact of marks you make when working with one color.

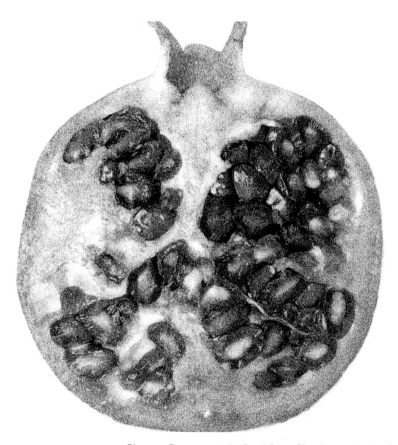

Bhagawa Pomegranate by Coral Guest (Graphite and carbon)

65

A little color can go a long way

Try a touch of color in a monochrome drawing. This can really draw the attention and add emphasis. Black and gray also need color to enliven them, particularly in relation to the color of animals' fur, for example.

Small Spaniel by Gayle Mason (Colored pencil); The touch of color makes the eyes the focus of this commissioned drawing.

Drawing Class by Katherine Tyrrell (Graphite); Changes in tone are achieved through the use of different graphite grades rather than pressure.

66

Punch the darks

Darks help you see the light. A very common mistake among those new to drawing is a failure to use the full tonal range and, in particular, to use the darkest darks too sensitively. Drawings are often too pale.

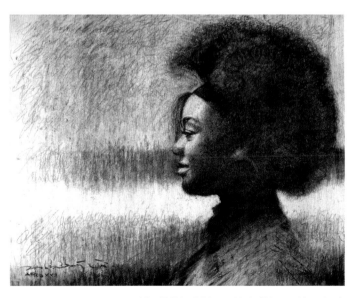

Afro XXII by Adebanji Alade (Charcoal/graphite); This uses a charcoal wash technique.

WORKING IN COLOR

Color is about so much more than a color wheel.

LEARN ABOUT COLOR

These terms are commonly used to describe the properties of color:

- **Local color**: Natural color seen in ordinary daylight, unmodified by bright light or shadows. Color can look very different in artificial light.

- **Hue**: Color in its natural state, without any tint or shade.

- **Value**: The position of a hue on the spectrum of light (tint) and dark (shade).

- **Tint**: A hue mixed with white.

- **Shade**: A hue mixed with black (or its complementary color).

- **Intensity/saturation**: The quality of brightness and purity; colorfulness.

- **Color spectrum**: The range of colors visible to the human eye.

- **Color wheel**: A theoretical model of color relationships, focusing on three aspects:

 - **Primary colors**: Pure hues (which cannot be made from any other color).

 - **Secondary colors**: Mixes of pure hues.

 - **Tertiary colors**: Mixes of secondary colors.

- **High key**: Predominantly comprising light, bright tones.

- **Low key**: Predominantly comprising dark, muted tones.

- **Analogous colors**: Three or more hues which are adjacent on the color wheel; one is usually dominant and called the "Mother" color.

- **Complementary colors**: Two opposing colors on the color wheel.

67

Read about color

If you like drawing in color, try to learn as much as you can about how color works. Color theory is a huge topic and well beyond the scope of this book but some recommended reading is listed in the bibliography (page 168).

68

Color mixes vary

The process used to print color (CMYK) is different from that used to reproduce color on screen (RGB). Neither print colors nor digital colors work in the same way as those used by artists, which are mixed using pigments and dyes.

Culinary Color Wheel by Nicole Caulfield
(Colored pencil)

69

Color changes

Color varies according to the type of light (natural or artificial), the time of day, the season and where you are on the planet. Changing seasons lead to a change in the color palette of the world around us.

70

Color based on observation

In order to use color to its best effect, you first need to practice seeing the infinite variety of color that surrounds us and the subjects we draw.

It is very easy to draw a subject based on what you think you know about its color rather than the color you can see if you look carefully. Be prepared for colors not to be what you expect them to be. Trust your eyes, not what your brain remembers.

EXERCISE: OBSERVE HOW COLOR CHANGES

Carrying out a regular study of color is a useful exercise that will help to refine your appreciation of color:

1. Sketch the same view on a regular basis (e.g., once a week or month), paying particular attention to color.

2. Note how color changes through the seasons.

3. After 12 months, create a presentation of the color changes from month to month (or week to week).

Autumn at Sheffield Park, England by Katherine Tyrrell (Colored pencil);
Fall is a time when nature displays analogous and complementary colors.

INFLUENCES ON COLOR PERCEPTION

* **Light**: How well lit a color is.

* **Surface**: Texture and reflective properties of surfaces affect how a color appears.

* **Reflection**: Light on adjacent objects can be reflected onto the subject.

* **Tone**: Become good at reading value patterns in color and it becomes easier to see how to use color in a more expressionistic way.

* **Near neighbors**: Hues near and/or around another hue affect your perception of its true color.

* **Culture**: Different cultures value some colors more than others.

71

Improve your working light

Aim for lighting that enables you to see true and unchanging colors. I recommended that you:

* Work away from bright or harsh sunlight.

* Sit next to a north-facing window as this produces more constant light.

* Use blinds to control light coming through your window.

* Use daylight bulbs at night rather than normal interior domestic lighting.

72

Create a color isolator

The way you see a color is affected by other colors around it, and this can be confusing. It is easier to assess color if you isolate it. Close one eye and view the color through a small hole, using a piece of stiff card with a hole punched out, a rolled-up piece of paper, or through a loosely curled fist.

Ashley by John Smolko (Colored pencil);
An expressionistic use of color and marks.

MEDIA FOR DRAWING IN COLOR

A wide range of media can be used for drawing in color:

- Colored pencils
- Soft pastels
- Conté/hard pastels
- Colored marker pens
- Colored drawing inks
- Watercolor paint
- Colored paper
- Marker pens

Far right: Analogous colors—these are next to one another on the color wheel (blue, blue-green and turquoise).

Right: Complementary colors—these are opposites on the color wheel. When mixed they create wonderful colored neutrals or "mouse" colors.

73

Draw with scissors

Cut up colored paper into different shapes and arrange them to create an image of an object. Doing this will require you to think hard about shapes, values and colors, and to work in a more simplistic manner, using nothing more complex than big shapes and one or two colors.

"The paper cut-out allows me to draw in the color"

—Henri Matisse (1869–1954; discussing drawing using scissors and colored paper).

Winter Blues by Alyson Champ (Collage with colored paper);
This uses largely analogous colors.

TEXTURE

Texture describes the quality of a surface. Approaches to drawing texture vary from the photorealistic to abstracted, graphical and symbolic. All of these are influenced by the physical properties of the surface, the media and tools used and the mark-making characteristics and style of the artist.

74

Find your own style for drawing texture

Find ways to suggest texture in order to prevent drawings looking monotonous. Choose a texture you're interested in and study the approaches employed by different artists for drawing that particular texture. Find ways of drawing texture that match how you see things and suit your own style of drawing.

Knitting Wool by Paula Pertile (Colored pencil)

75

Address the issue of "more of the same"

Some aspects of subject matter involve a lot of repetition (e.g., hair, feathers, fur, roof tiles, bricks, windows, leaves) that can flatten texture. However, just because it exists doesn't mean you can see it, so don't draw what you can't see. Do you really want to draw every line or shape with utmost precision? Look for ways that simplify the texture while representing what you think is important.

Box by Alan Woollett (Colored pencil); This addresses the challenges of rendering several different textures.

Ripples by Katherine Tyrrell (Colored pencil); A stylized way of drawing water.

WORKING WITH REFERENCE PHOTOGRAPHS

76
Your own photographs are always the best

If you took the photograph, you will remember a lot more about the scene than the photo display. It will also be more likely to focus on subjects that interest you.

77
View reference photos on a backlit screen

LED backlit screens offer the best way of viewing a photographic image. The brightness and color range mean the screen image is much better than anything you can print.

PHOTOGRAPHS: COMMON DISTORTIONS

There are two types of common photographic distortion: Optical (associated with the lens) and distortions caused by perspective.

Optical distortions:

- **Tonal values are not true**: Shadows can appear much darker than they are in reality. Ensure you also have sketches that depict the real tonal range.

- **Color is distorted**: Cameras pick up light in different ways and colors are often not "real." Chromatic aberration produces colored fringes.

- **Barrel distortion** (wide-angle lens): Lines bend outward from the center (see opposite).

- **Pincushion distortion** (telephoto lens): Lines appear to bend inward and toward the center (see opposite).

- **Vignette**: Image is brighter in the center and darker at the edges.

Perspective:

- **Perspective distortion**: Straight parallel lines converge. This is usually associated with looking up or down.

78
Never use photographs without permission

Four reasons why you should never use other people's photographs without a proper written license:

- **Copyright**: You need written permission (a license) to use someone else's photo.

- **Financial**: Infringe copyright and the copyright owner can send you an invoice or seek to recover your financial gain or their loss through the courts.

- **Reputation**: Your work may be rejected from an open exhibition or art competition if it is not entirely original and your own work.

- **Prizes**: You may have to return a prize.

HOW TO LIGHTEN SHADOWS

There are lots of tutorials online about how to lighten shadows using image-editing software. The Shadow and Levels features in Photoshop Elements are useful:

- Use the Shadow/Highlight adjustment to lighten dark shadows in the image.

- Use Levels to adjust the histogram for each RGB color.

79
Adjust distortions in photographs

Certain digital image-editing software programs, such as Photoshop Elements, will allow you to adjust these distortions.

PHOTOGRAPHS AND TONAL RANGE

Photographs are very poor at showing correct tonal values. They are best used as a source of reference material only (to show detail in a subject, for instance) alongside sketches that show the real tonal range.

80

Five ways to avoid distortions

It is not difficult to tell drawings copied from a photograph if no adjustment is made for common photographic distortions. The best way to avoid distortions when taking photographs is to know how they happen and to take the time to avoid them. A few simple measures will help:

- **Stop snapping**: Make the time to take properly composed reference photographs.

- **Adjust your camera for the type of light**: The quality of your reference photographs will improve if you use a camera that can manually or automatically adjust for different light levels.

- **Get a tripod**: Take a steady photograph at the right angle and level. You should aim to get the lens parallel to the subject rather than at an angle.

- **Move yourself as well as the zoom**: Work out how you can get on a level with the subject to reduce distortion associated with perspective.

- **Study the image on the camera screen before you take the photograph**: Always check the verticals and horizontals, and take your time.

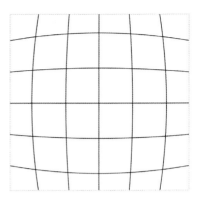

Barrel distortion by WolfWings via Wikimedia Commons.

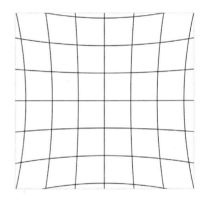

Pincushion distortion by WolfWings via Wikimedia Commons.

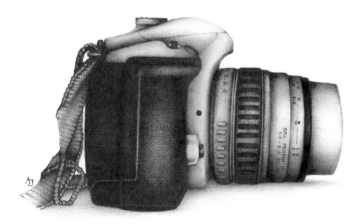

Camera by Andrea Joseph (Ballpoint pen)

This optical distortion of converging lines is a problem of perspective.

WAYS OF DRAWING PICTURES

You can think on paper by drawing. This section highlights how the principles of design can be employed to make drawings more effective.

PRINCIPLES OF DESIGN

These are the principles of design as taught in art schools:

- Balance and harmony
- Emphasis
- Unity and variety
- Pattern
- Rhythm
- Movement

81

Draw what's important to you

This is really important. A drawing will only be interesting if you draw what interests YOU! I happen to love the macro patterns created by flowers and plants.

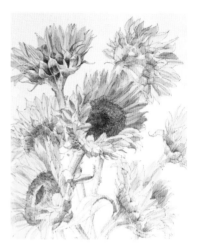

Sunflowers by Katherine Tyrrell (Pen and ink); It's the same sunflower drawn again and again.

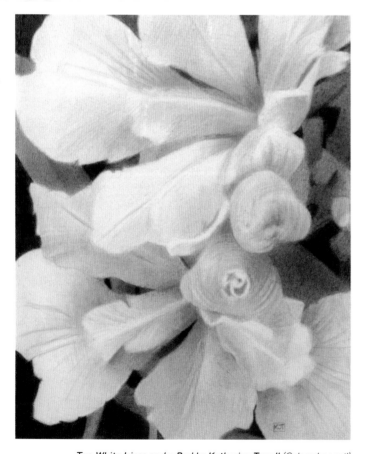

***Two White Irises and a Bud** by Katherine Tyrrell (Colored pencil)*

My thumbnail sketch for Two White Irises and a Bud.

START BY SIMPLIFYING

Think of ways to simplify your subject. Simpler drawings tend to work better than more detailed drawings, which can sometimes look old fashioned and fussy.

A THUMBNAIL SKETCH

A thumbnail sketch is a simplified and very concise way of representing an image as it:

- Eliminates *all* the detail.
- Reduces a picture to its basic elements.
- Tests out how to draw the subject.

It's an important device that is used a lot as a preparation stage by people who draw and paint.

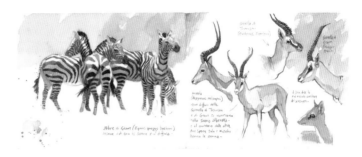

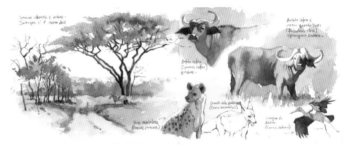

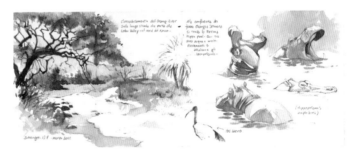

Small Sketches of Wildlife in the Serengeti by Federico Gemma (Watercolor); Sketching small creates many different views of an animal and helps develop ideas for how to portray it in its context.

82

Create lots of thumbnail sketches

Plan your proper drawing using thumbnail sketches (see left and page 68). Don't do just one; do lots to exercise the visual muscles in your brain.

Practice develops confidence:

- Work small and simplify—draw a small box.
- Work in monochrome or grayscale (pencil or marker pen).
- Use a maximum of three values to simplify and shade the value pattern.
- Identify the focal point.
- Work out what to emphasize and what to remove.
- Identify any clear contrasts.
- Identify lines that lead the eye into the focal point.

83

Test your thumbnail sketch

Your first idea isn't always your best. See if you can improve on it. Test alternative options for designing your drawing. Think about different perspectives/angles on the subject and examine scope to vary the tonal pattern. Try different picture formats (e.g., portrait, landscape and panoramic) and test different crops. Review different ratios of height to width (see pages 54–55).

FORMAT AND CROP

84

The four most important lines

The four most important lines are the edges of the drawing. When drawing you must decide:

- **What to include in the drawing:** You don't have to draw everything you can see.

- **The picture format to use:** Portrait (vertical) or landscape (horizontal).

- **The dimensions and the aspect ratio:** This is the ratio of the height of the image to the width. There are a number of standard ratios related to frame and paper sizes.

- **Cropping:** Where to draw four crop lines around the subject.

85

Reflect on how the eye navigates around a picture

People read pictures the same way they read books. If a person reads from left to right, then they will typically approach a picture in the same manner. If a picture makes you feel uncomfortable, but you can't work out why, try thinking about how your eye tracks through the picture.

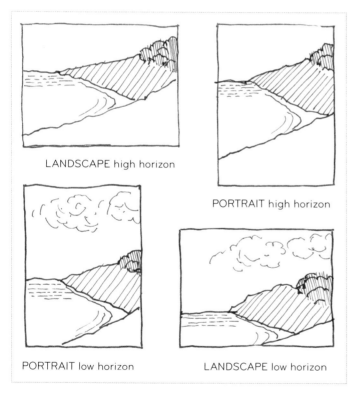

The same scene but different content; the crops are based on high and low horizons in portrait and landscape formats.

Fried egg composition: Amateur artists often start by placing their subject in the center with equal space all around (see Tip 87).

86

Pre-draw frames for your sketches on your paper

Sometimes the simple act of drawing a frame for a sketch or drawing on your paper before starting prompts you to think more carefully about how a work is "framed."

CHECK THE ASPECT RATIO

Develop your own viewfinders for different formats. Common formats are 6:4, 7:5 and 10:8. These can multiply up for working in common formats such as:

- **6:4**—12 x 8in., 15 x 10in., 24 x 16in., 30 x 20in.

- **7:5**—14 x 10in., 28 x 20in.

- **10:8**—20 x 16in., 30 x 24in.

HOW TO FIT YOUR SUBJECT TO A FORMAT

A pathway from subject to cropped image:

1. Identify a potential subject.

2. Determine why you want to draw it—what do you like best about the subject?

3. Identify the focal point of interest (see pages 56–57).

4. Decide what to leave out of the drawing (i.e., the elements that add little value).

5. Use a thumbnail sketch to decide how to frame and locate the focal point within the drawing (see page 53).

6. Experiment with portrait as well as landscape formats.

7. Decide on the aspect ratio and dimensions.

8. Determine the crop lines.

9. Identify additional space needed for framing (see pages 70–71) and add this to the paper to be used.

10. Incorporate the four crop lines into the drawing.

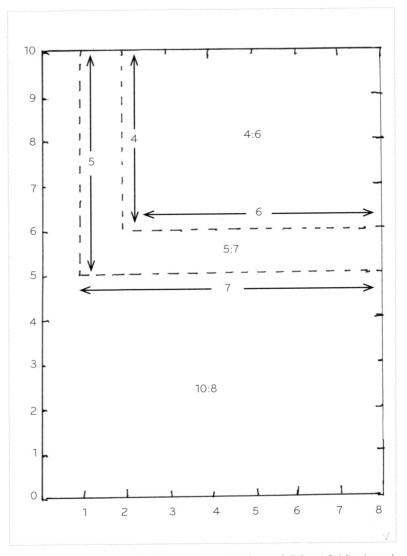

The aspect ratios for different formats: 10:8 (portrait), 7:5 and 6:4 (landscape).

EMPHASIS, FOCUS AND CONTRAST

Your aim is to create a drawing that leads the eye to the center of interest, also known as its focal point. What do you want people to look at?

87
Anywhere but the center

Identifying an element of a picture as the center of interest does NOT mean it should be placed in the center of the frame. Avoid the bull's eye approach; place your emphasis and focal point off-center (see page 54).

90
Use the golden ratio as a guide

The golden ratio (or mean) is a classic guide to composition. It refers to a specific ratio (1:1.618, or approximately 3:5) of height to width, or vice versa. It is a traditional method of dividing up the pictorial space to create a harmonious picture.

Emphasis is maximized if the focal point is placed on the sweet spot, where the vertical and horizontal lines intersect (see image right).

91
Rule of thirds

The rule of thirds is an approximation of the golden ratio. Your camera probably has the option to apply a grid to the viewfinder or screen.

88
Create emphasis

Drawings need emphasis to be interesting and to draw the eye to a dominant part of the composition. Options include:

* Stress one element of a drawing.
* Intense color
* A very large or very small shape.
* Marked contrast: A very dark or very light tone.
* The interruption of repetition.
* The direction of lines.
* An intersection of shapes or lines.
* Use of words in a drawing.
* Subordinate less important parts of a drawing.

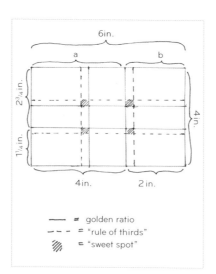

The relationship between the golden ratio and the rule of thirds. The length of line A divided by B = 1.618.

89
Create contrast

Contrast is an effective way to emphasize detail, create interest and fix the focal point within a drawing. There are various ways to create contrast:

* Variation in the weight of lines.
* Use of toned paper to make lights and darks pop.
* Use of color (complementary colors are a good example).
* Extreme variations in size.
* Variation in shape (e.g., one different shape in a group of similar shapes).
* The juxtaposition of areas of empty space with areas of greater detail.
* Use of light direction to create a marked contrast between tonal values.

92
Review other artwork

Try analyzing the design of artwork by famous artists and see the extent to which it conforms to the golden ratio. Many artists locate the horizon line of their landscape or seascape according to the golden ratio. It is important to note, however, that the dimensions of many standard picture formats and paper sizes do not conform to the golden ratio.

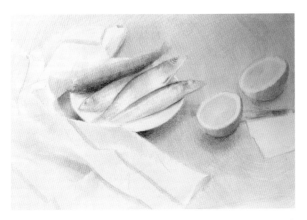

Four Fish Out of Water by Katherine Tyrrell (Colored pencil);
The red around the gills draws the eye.

Ecology Park Pond #1 by Katherine Tyrrell (Colored pencil);
Detail of the flats in the background is subordinate to the pond.

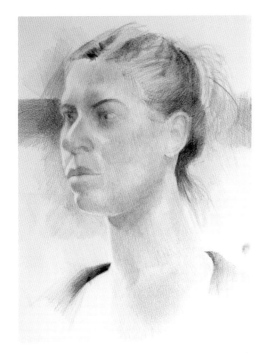

Drawing a Head by Katherine Tyrrell (Colored pencil);
The darker shaded area in the background
gives definition to the form of the head
and lends emphasis to the eyes.

*After Tom Girtin—The White House at Chelsea by
Katherine Tyrrell* (Colored pencil); Girtin created
emphasis through contrast of color and tone.

BALANCE AND HARMONY

LEARN ABOUT BALANCE AND HARMONY

The following can be used when describing a drawing in terms of its balance and harmony:

- **Asymmetric**: An absence of symmetry; the two sides of the drawing are not the same.

- **Balance**: A principle of composition; a method for weighing different elements.

- **Dissonance**: The incongruence of contrasting and conflicting elements; it can be unsettling and can produce tension within a drawing.

- **Dominant**: Describes an aspect of the drawing that has more weight.

- **Dynamic balance**: A harmonious arrangement of elements of creative tension.

- **Harmonious**: Describes an aesthetically pleasing arrangement of elements.

- **Monotonous**: Describes a visually uninteresting arrangement, where everything is the same.

- **Repetition**: A major way in which balance is achieved; it can take various forms.

- **Static**: Completely balanced (i.e., symmetrical around the central axis); an absence of movement.

- **Symmetrical**: Describes drawings in which both sides of a central (vertical or horizontal) axis are the same.

- **Unbalanced**: Describes drawings in which visual interest is largely on one side.

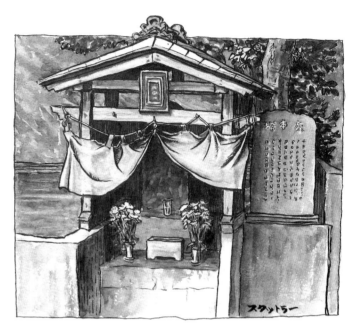

Corner Shrine, Tokyo, Japan by Russ Stutler (Brush, ink and watercolor); An example of a balanced drawing with a quiet harmony; it includes subtle asymmetry.

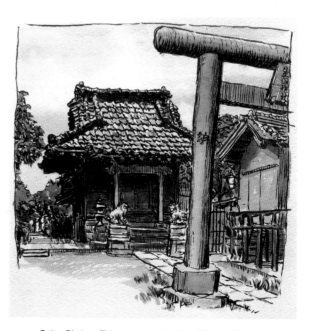

Seita Shrine, Tokyo, Japan by Russ Stutler (Brush, ink and watercolor); The use of a strong vertical in the foreground is characteristic of 19th-century Ukiyo-e woodcuts by Japanese artists.

93

Why balance is important

Balance, in the context of an artwork, refers to the properties of a drawing that make it pleasing and harmonious. It is affected by the size and positioning of details in a drawing and can be the reason why some drawings are more disturbing than others.

The Sushi Shop, Tokyo, Japan by Russ Stutler (Brush, ink and watercolor); The background is understated, but the verticals repeat the dominant vertical in the foreground.

94

Decide background treatment at the beginning

A classic characteristic that betrays amateur art is a preoccupation with drawing the subject and subsequent neglect of the background. Background detail is not less important just because it is positioned behind the subject. Decide at the start how you will treat the background of your drawing.

95

Avoid being boring

People automatically try to pair and group an even number of items. This stops them looking at the subject matter. Also, symmetry is rather like hard edges—if you have too much, your drawing becomes boring and visual interest diminishes.

This is the reason why people love faces with character; the broad symmetry of a typical face is less interesting than the unique distribution and dimensions of its features.

96

Think about balance

Drawings by beginners can be either static and symmetrical (and boring) or somewhat chaotic, with little logic behind what goes where. Balance and harmony are not present in drawings that are unresolved or incomplete or in those intended to make people feel something's not quite right. Learn about balance and harmony, and you can begin to resolve the competing elements of visual interest.

UNITY AND VARIETY

Unity and variety are complementary. Unity is achieved when various, and even dissimilar, objects look as though they belong together in a drawing. Variety adds interest. Contrast and difference prevent a drawing from being boring.

97

How to create unity

You can achieve unity in your drawing through a number of techniques:

* The use of harmonious and analogous colors.

* The repetition of similar shapes, colors and tone.

* Harmonious methods of mark-making.

* Careful selection of subject matter.

* The use of proximity (i.e., the nearness of objects to each other).

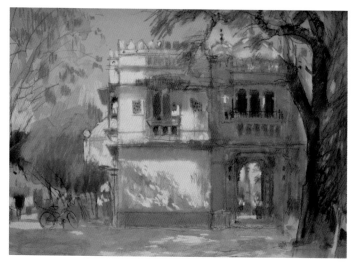

Udai Bilas Palace in India 1 by Felicity House (Pastel); *This is one version of the entrance to the palace.*

98

How to create variety

A drawing can be boring if it contains too little variety. Achieve interest and variety through:

* The use of an odd rather than even number of objects.

* Variations in different elements such as lines, shapes, the sizes of those shapes, colors and textures.

* Variety can also be reflected in a series of drawings of the same subject—where the light or weather changes the tones and colors (see right and "Canary Wharf Skies" on page 118).

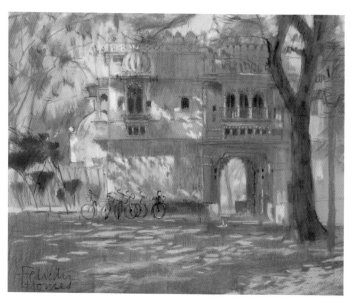

Udai Bilas Palace in India 2 by Felicity House (Pastel); *Here's another version, with exactly the same shadows but a completely different palette.*

Pura Ulun Danu Bratan by Katherine Tyrrell (Pastel); This water temple in Bali, Indonesia is surrounded by sunshine, low cloud, plus a slight breeze on the water. What interested me was the variety in the light. The temple on the left was dark against light and the one on the right was light against dark—simply because of how the cloud changed in the background. In addition, these were similar shapes but different sizes. I pushed the color and emphasized the complementary colors—acid-yellows and purple-blues, greens and crimson.

Diva by Loriann Signori (Pastel); Loriann uses analogous colors to achieve the striking tonality of her pastel artwork. She also adds variety by pushing her colors to create wonderfully colored darks.

RHYTHM, REPETITION AND PATTERN

LEARN ABOUT REPETITION

- **Motifs**: A recurring detail or element.
- **Pattern**: The organization of repeating elements of a design.
- **Repetition**: Multiple usage of a detail or element.
- **Rhythm**: A visual beat.

Iznik Ceramics in the Victoria and Albert Museum by Katherine Tyrrell (Colored pencil); Man made forms that echoed natural forms (e.g., tulips). I created extracts which repeat motifs and colors.

99

Create a motif through repetition

If a pattern within a drawing is repetitive and significant it's called a motif.

Drawing offers the opportunity to repeat shapes using line alone rather than more solid shapes.

The motif of an artist can be the pattern created across a significant number of drawings.

100

Seek out and use repetition

Repetition is important in drawing and art. It involves repeating shapes, lines, tones or colors and has a number of functions. It can promote balance, harmony and unity within a drawing, and create rhythm and pattern. Note that your eye tends to travel around a pattern looking for small differences. In the illustration of garlic here, the bulbs are similar yet different, which keeps some eyes scanning the image.

101

Observe patterns in your world

A pattern can be a natural or a deliberate design. As you learn to see and observe patterns, you'll find you see more and more of them in the world you live in. The patterns you notice the most are likely to be those that are attractive to you, but you may not necessarily spot this straight away. It took me ages to realize that I loved drawing the two extremes of patterns—relating to micro views of flowers and plant structures, and macro views and patterns within the landscape.

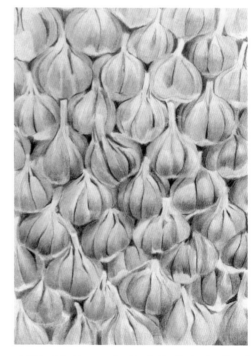

A Wall of Ophioscorodon (Garlic) by Katherine Tyrrell (Colored pencil); A man-made arrangement of natural forms.

MOVEMENT

102

How to lead the viewer's eye

The viewer needs a way in and out of a drawing if they are to avoid feeling confused.

Movement shows the way; for example, the inclusion of zigzags and diagonals is a common way of leading the eye through a drawing.

103

Drawing with the flow

I'm very envious of those artists who can draw with a flow that creates a poetical line. Then again, the more I draw, the more I notice that the flow of my drawing becomes more instinctive.

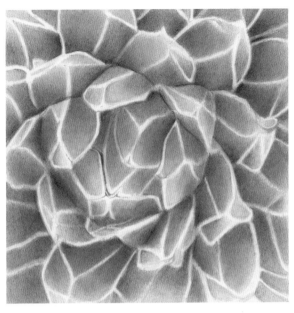

Tesselation #1 by Katherine Tyrrell (Colored pencil); A rotational form that uses repetition of shapes.

Gray, Green and Pink in Yuma, Arizona, USA by Katherine Tyrrell (Colored pencil); This piece derives movement from directional lines, diagonals and rhythm relating to pattern and color.

HOW MOVEMENT LEADS THE EYE

Eye movement in art relates to how the eye views an artwork.

Regular repetition of any element of design creates movement.

The design of shapes and lines can suggest movement. For example:

- Lines can be directional, undulating, flowing or jerky.
- Rotational shapes create circular movement.
- Verticals and horizontals tend to constrain movement.

Resolution attracts the eye. Highly resolved areas become centers of attention while unresolved areas lose attention.

ACCURACY VS. CREATIVITY

There is no requirement to draw accurately or realistically.
Realism, on the other hand does not preclude creativity.

"Drawing is putting a line round an idea."
—Henri Matisse (1869–1954)

*Pinboard by Andrea Joseph (Pen and ink); An intricate still life with elements
of self-portrait. Try collecting lots of small objects that relate to your life and
construct a portrait as a still life.*

ACCURACY

Three factors determine whether
a drawing is accurate:

- **Observation:** Do you draw what
 you know or what you see?
 Do you see reality as it is or as
 you think it is?

- **Memory:** How well do you
 remember what you saw between
 seeing it and recording it? Over
 time, it's possible to train your
 brain to remember visual
 information for longer.

- **Personal perspective:** This
 dictates what subject we choose
 to draw and which elements
 within that subject we choose to
 emphasize. This largely depends
 on what interests us. We are
 allowed to change what we see.
 We can also focus on what we
 like and leave out what doesn't
 interest us.

104

Commit to observation

Accuracy improves if you use ways of
making marks that you cannot undo—
this forces you to observe your subject
more acutely and take greater care
when making the marks.

*Aloe by Katherine Tyrrell (Colored pencil);
My style is to look for the abstracted shapes and patterns in macro views of
plants and flowers. It's based on realism but highlights the abstract.*

105
Realism in drawing includes a range of styles

Realism is about representing a subject in a truthful way. However, this is not the same as photorealism, and does not necessarily require pinpoint accuracy. Explore how mark-making can be abstracted close-up and realistic from a distance.

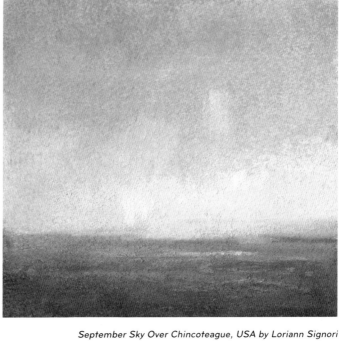

September Sky Over Chincoteague, USA by Loriann Signori *(Pastel); A simple subject, careful observation and an element of creativity.*

106
Develop your own style

There's a *big* trade-off between style and accuracy. The more accurate you are when copying photographs, the more difficult it is to show how your drawing is unique and individual to you. Develop your own unique style of drawing by trying to focus on subjects and ideas that interest you. Stop copying photographs and try to become more relaxed about precision and accuracy. Explore how you can make marks that are less than precise and convey more than just shapes. (See also pages 24–25).

107
Develop creative habits

Become more confident in your ability to be creative.

- Be curious and ask "what if...?"

- Let your mind wander.

- Get in the zone for periods of intense concentration. Act on your insights—connect the dots.

- Try new ways of making drawings.

- Make your drawings unique.

- Be resilient—failure is normal.

- Evaluate at the end, not at the beginning.

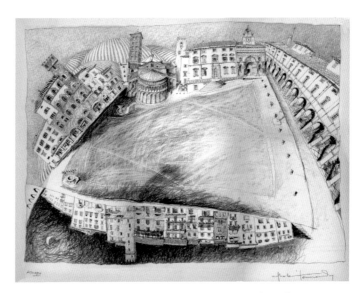

Piazza Grande, Arezzo, Italy by Mat Barber Kennedy *(Pencil); This drawing is influenced by a pre-Renaissance painting. It's also driven by experience and a narrative view rather than rules of perspective. It's Mat's own unique view of this well-known piazza.*

HOW TO PROGRESS

SELF-ASSESSMENT AND IMPROVEMENT

Developing a critical eye and a critical brain are two really important ways of making progress with drawing.

108

The like/dislike/ improve exercise

Identify one thing you like about a drawing and one thing you don't like. Verbalize and explain your likes and dislikes. Work out a strategy to enable you to repeat the aspects you like and avoid those you dislike. Reflect on whether your likes and dislikes remain the same or change over time.

109

Reflect on your drawing

Put your drawing away out of sight and leave it for a lengthy period without peeking. Take another look at it. You'll find you look at it with fresh eyes.

EXERCISE: MAKE A CHECKLIST

Create a systematic checklist of questions specific to the aspects of drawing that you find particularly challenging. For example:

Purpose

- Is the purpose of the drawing apparent?
- Is there a clear focal point?
- Did you achieve what you set out to do?

Technical details

- Are the medium and support appropriate for the subject?
- Did you experiment—for example, with new media?
- Are the shapes, size and angles correct?
- Does the design make good use of space?
- Is there a clear value pattern?
- Are zones of interest clearly defined (e.g., foreground, middle ground and background)?
- Is the mark-making varied?
- Are proportion and perspective rendered correctly?
- Do the colors used enhance the subject matter?
- Are all areas resolved?

110

Study and learn about good drawings

Develop your appreciation of the range and scope of good drawing by studying a wide range of examples in art books and online museums, and viewing them in exhibitions or the collections of art galleries and museums. You don't have to like them all, but it's interesting to try and work out why a drawing has been included in a museum, exhibition or art book.

After J.M.W. Turner's Snow Storm—Steam-boat off a Harbor's Mouth by Katherine Tyrrell (Colored pencil); One way that I continue to learn is by producing drawings based on paintings by the Masters.

PEER ASSESSMENT

Seek out people who will provide honest and critical analysis as well as praise.

111

Join an art group or society

National and local art societies are two extremes. The hobby artist often dominates local art societies, whereas members of national art societies tend to be professional artists. It's worth finding out if the art societies near to you tend to take drawing seriously and can help you progress. It is often possible to find tutors, art groups or educational organizations that run regular life-drawing sessions.

112

Develop the ability to critique

The first rule of critique is to avoid commenting on another person's drawing unless asked. Remember that not everybody wants a critique. If asked, identify something positive to say first. Talk about something you like about the drawing. Then identify an aspect that you like less, and ask the individual why they think that might be. Finish with a comment about an aspect that shows promise and has the potential to be improved.

113

Find a critical friend

Uncritical compliments are unhelpful. Develop your own peer assessment group, making sure these are people who are knowledgeable and who you can trust to be honest, and discuss your drawings with them.

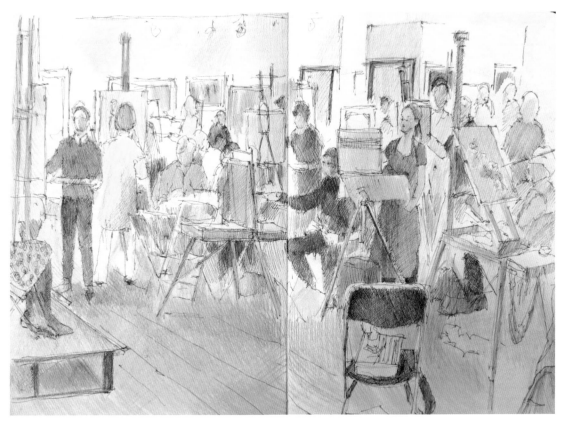

Art Society Event, Mall Galleries in London, England by Katherine Tyrrell (Colored pencil)

DEVELOP YOUR DRAWING

114
Practice, practice, practice

People often want to know how long it takes to become good. A common answer is about 10,000 hours—no matter what your subject. The sure way to develop and improve is to practice drawing and sketching on a regular basis.

115
From sketching to drawing to fine art

There comes a point when you want to work on good-quality drawing paper rather than in a sketchbook and create drawings for other people to see. In time, you can progress to producing fine-art drawings with the intention of submitting them to open exhibitions and art competitions.

My sketches for the first London Urban Sketchers Exhibition.

116
Develop sketchbooks for examination or entry to art school

Sketchbooks are a good way to demonstrate how you draw from observation, work through themes and explore ideas and different media.

117
Keep a studio sketchbook

A studio sketchbook is a record of work being produced and contains a host of valuable information, including ideas for drawings, initial thumbnails for working out value patterns, diagrams of crop options, possible names for works, calculations relating to matting and framing work, notes about art materials used and art supplies shopping lists.

118
Develop your career

Skills in drawing from observation can be critical to those wanting to develop a career as an artist. Art schools and art societies can ask to see sketchbooks and examples of drawing from observation.

119
Write about drawing

Verbalizing what you do very often prompts you to review the reasons why you did it.

Studio Sketchbook by Sally Strand (Marker pen); Thumbnails of light in a Paris flat, used subsequently to develop a larger artwork.

ADVANCED DRAWING PRACTICE

December Rain by Barbara Benedetti Newton (Pastel); Barbara went from being a working mother to a leading colored pencil artist and author before switching to soft pastels. She now also works in oils.

120

Record your drawing process on video

Study the processes you use. Do you have any bad drawing habits?

121

Make yourself use another format for a month

If you normally work on a small scale, try working on larger drawings. Don't allow yourself to draw in your comfort zone for a month. At the end of the month, assess whether you have now extended the scope of your comfort zone.

122

Explore different drawing media

Change your usual drawing media and/or explore using more unconventional media. For example, switch from paper-based work to using a digital tablet for sketching, or try printmaking.

123

Study an artist

Study how he or she draws and try to copy what they're doing and how they're making marks. Work out what you've learned from that artist by emulating their drawing process.

After Bellini by Ilara Rosselli del Turco (Monotype); A study based on Giovanni Bellini's Madonna of the Small Trees.

PREPARING TO FRAME

This section is useful if you plan to frame your drawings
for exhibitions or to display at home.

124

Frames fit for purpose

To exhibit and/or sell your drawings you need to
know what type and color of frames/moldings and
mats are favored in the place where you hope to
exhibit (e.g., a gallery or open exhibition).

125

Think about size from the start

It is easier and cheaper to mat and frame a
drawing if you have thought about the format and
size of your drawing before starting. This is
because idiosyncratic sizes require custom-made
mats and frames. Customized frames are typically
hand-made and more expensive than standard-
size frames. Standard-size mats and frames can
also be reused more easily for new drawings. In
general, frames are categorized by the size of
opening, not the external size of the molding.
The interior size needs to accommodate both
image and mat. A wide mat looks better than a
narrow mat. Frames can be purchased in standard
sizes (e.g., 8 x 10in.; 12 x 16in.) from a wide range
of suppliers.

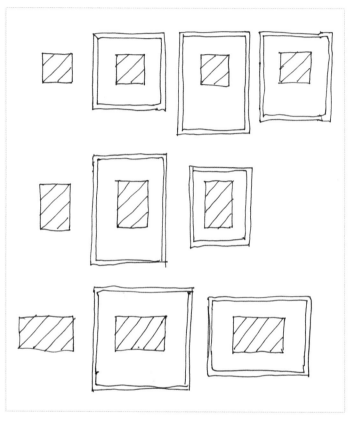

How image shape relates to mat and frame. Use the mat
to allow the drawing space to breathe within the frame.

126

Allow for margins

The mat or the frame will hide some of your
drawing if you draw to the edge of the paper.
Leave a big margin and you will have scope to
change the four lines around the drawing. Lightly
draw a frame in pencil to work within the paper,
making sure that this pencil frame has 90-degree
angles. Work across and into the margin when
drawing. This is the area under the rebate.

127

Clean, then frame

Before sealing the frame, you must clean your
work, the frame and the glass. Remove all loose
media and clean up any visible dirty marks. Use
compressed air to remove all dust and debris from
the art, mat and inner side of the glass. Use glass
cleaner with a lint-free cloth to clean both sides of
the glass. Seal with gummed tape at the rear to
prevent dust and insects getting in.

128

How to size your drawing for framing

Start in one of two ways:

Starting with the frame

You need to know:

- The size of the interior of frames you prefer/can afford. They all have an internal rebate—the part where the mat overlaps the frame so it's held secure (marked with hatching on the diagram).

- Check whether the internal dimensions include or exclude the rebate (i.e., does it relate to the visible window for the mat and image?)

Calculate:

The dimensions of the visible image after allowing for a comfortable margin for the visible mat (which is usually wider along the bottom) and the rebate for the mat (i.e., the bit that's hidden).

Starting with the drawing

You need to know:

- The best shape for the picture plane (i.e., portrait or landscape) and ratio of height to width. This applies irrespective of actual size.

- The best size (small, medium or large). Test different sizes by adding on space to your drawing to incorporate a mat.

- Work out the margins for the mat (wide tends to look better than narrow, which can often look mean and cheap).

- A deep frame at the bottom lends weight to the image, which looks better.

- Remember to include the margin for the rebate of the frame within your mat margins.

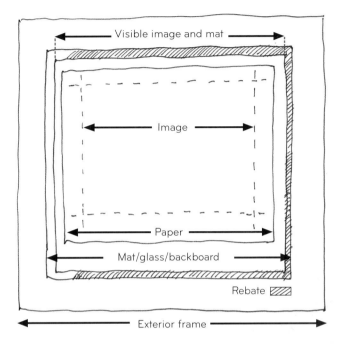

BACK: How paper and image size relates to mat and frame.

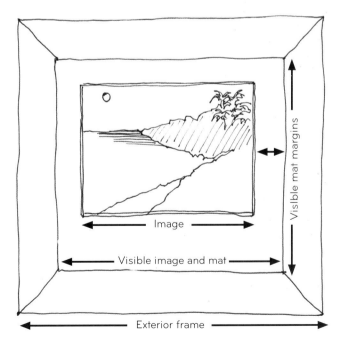

FRONT: How image size relates to mat and frame.

2. DECIDING WHAT TO DRAW

Places provide the context for life, and life enlivens places. Your drawings will be more interesting if you develop the skills to draw both. This chapter focuses on:

• Drawing from life: still life, people, animals and nature.

• Drawing places we see and visit: our homes and other interiors as well as a range of environments and scenes we may encounter in the outside world.

A Summer Garden in Cheshire,
England by Katherine Tyrrell
(Pen and sepia ink); I regularly
draw my mother's garden
through the seasons.

DRAWING FROM LIFE

STILL LIFE

Still life is the simplest thing to draw from observation because it does not move, and you don't need a reference photo for simple setups.

129

Draw one object

When drawing from life, keep it very simple to start. Set yourself the task of choosing one object within the home and drawing it.

130

Think odd numbers

An odd number of similar objects, such as round objects, in a setup almost always works better than an even number.

THINGS TO DRAW IN THE HOME

If you're a newcomer to still life, improve your skills by drawing lots of simple objects. Those found in the home are a good place to start:

- Faucet
- Sandwich
- Clothes
- Cupcake
- Paintbrush
- Table lamp
- Fruit such as an apple or pear
- A bottle of water
- Egg in an egg cup

DRAW MULTIPLE BUT SIMILAR OBJECTS

Draw multiple objects that are similar in size, shape or texture, such as:

- Flowers
- Fruit in a bowl
- Cheese on a board
- A child's building blocks
- A collection of bottles
- Salt and pepper shakers
- A collection of shoes
- A pile of books
- Cats or dogs asleep

TYPES OF STILL LIFE

- **Found**: The objects are set out in a way that suggests the artist has chanced upon the arrangement. The risk, however, is that an arranged "found" can look false.

- **Narrative**: A still life arrangement that tells a story.

- **Purely aesthetic**: An arrangement of objects and colors intended purely to attract the eye.

- **Purely conceptual**: Focuses solely on a concept, such as the exploration of form.

- *Momento mori*: Popular historically, this type of arrangement recalls a life past and acts as a reminder of life's passing.

A Pear by Katherine Tyrrell (Colored pencil); The pear is a fruit beloved by the still life artist.

Citrus by Nicole Caulfield *(Colored pencil); Part of a series of square foodie drawings. This one has a nice contrast of complementary colors and shapes.*

131

Explore shapes

Develop a collection of objects of different shapes and draw them again and again in different arrangements, and in monochrome and color. Paul Cézanne used apples and oranges, and Giorgio Morandi used bottles and jars to explore the beauty inherent in very simple shapes.

EXERCISE: DRAW AN OBJECT IN CONTEXT

Start with one object and draw that. When you feel ready, add in another object that is similar to the first. Next, draw the context for the object —a very normal found scene within the home. There is no need to arrange the objects—just draw what you see. Try to avoid leaving lots of space around the objects. Instead, crop in close to them.

Coffee Cans in the Conservatory by Felicity House (Charcoal);
This piece highlights the role played by lighting and shadows.

132

Backgrounds are important

In successful still life drawings, the background is rarely flat, even if it's not obvious at first glance. The skill lies in creating interest in very subtle ways, through marks made or slight shifts of light and hue.

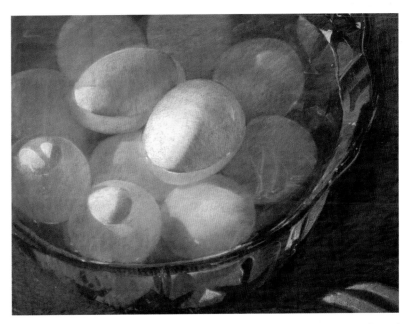

Eggs Underwater by Sally Strand (Pastel)

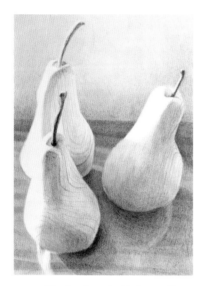

Wooden Pears by Katherine Tyrrell (Colored pencil); This arrangement of pears always seemed to me to have an underlying narrative.

HOW TO MAKE A SHADOW BOX

A shadow box enables you draw a still life with constant light from one direction, including any interesting shadows that your subject casts. Create a box with one open side (large appliance boxes are good for this as the flaps help control the light).

Paint the interior or line it with sheets of stiff black, white or colored paper, card or foam. Vary shadows and the way colors are reflected by using different materials for the base such as a sheet of glass, a mirror or a sheet of white paper.

The box needs to be deep enough that it creates a space that is shielded from artificial room lighting and natural light from windows. The height of the box needs to accommodate the height of still life subject matter, so use smaller boxes for apples, for example, and taller boxes for vases of flowers.

To create controlled directional lighting, cut holes in two sides (the top and/or the left side) and fix a light so that it shines through one hole and onto the subject. Diffuse the light by using muslin or gauze pinned over the hole. It's *essential* that hot lights are not put next to flammable materials.

To draw, place the box, its contents and lighting at eye level so you can see the contents clearly.

133

How to light a still life

In almost all western drawing and painting it is customary for the light source to be on the left. This is because our eyes are accustomed to move from left to right when we are reading words or scanning a drawing.

134

Use a shadow box

Shadow boxes have traditionally been used to control the lighting of a still life setup. They're not too difficult to make and you can follow the instructions provided above.

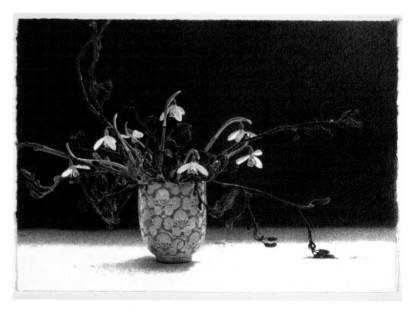

Out of the Wood by Sarah Gillespie *(Charcoal); This is a very effective use of monochrome, portrayed with a controlled background and lighting.*

DRAW COMPLEX STILL LIFE SUBJECTS

When you feel more confident, progress to more complex assignments such as:

- The items on a breakfast table
- Ingredients for a meal
- A meal in a restaurant
- An artist's work bench
- A kitchen countertop
- A collection of bottles
- Vases full of flowers

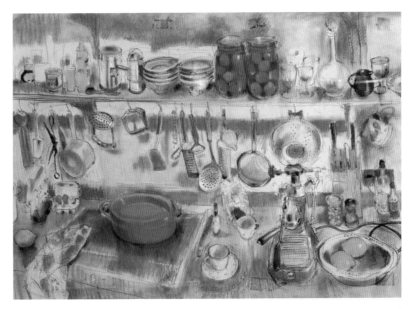

Two English Plums by Felicity House (Pastel)

135

Photograph objects that may deteriorate

Draw from life but also take reference photos if items are perishable and likely to deteriorate before you finish your drawing.

Lunch in a French Restaurant by Katherine Tyrrell
(Colored pencil); Drawn as it arrived at the table.

136

Draw a restaurant meal

Create a composition and pleasing picture without knowing what it will contain before you start. This also teaches you to focus on shapes and repetition and to draw fast.

137

Create a self-portrait as a still life

Create a still life setup by collecting together items that have meaning for you— objects that tell the story of your life, or an event or period in your life. Think about how the shape, lighting and arrangement indicate the relative importance of the individual objects.

PEOPLE

The next ten pages provide advice on drawing people in different contexts. Learn about drawing the head and the clothed figure as well as life drawing and drawing groups of people.

WATCH AND DRAW

Start by observing and drawing people you see every day:

- On television.
- Friends watching television.
- Family around the house.
- Traveling in cars.

Next draw individuals in public places who do not move a lot and who are not friends or family:

- In queues and waiting rooms.
- Artists in life classes.
- Students watching artists demonstrate their techniques.

138
Draw people from observation

Before you can draw people, first you have to find people to draw. Observe and draw people outside life class. Models are expensive to hire so think about alternatives (see left). There are a number of inexpensive ways to observe people who stay put and those who move around.

139
Draw shapes in public and likenesses in class

Figure drawing is not portraiture. Drawing people from observation is not the same as drawing an individual. When drawing people you don't have to achieve a likeness. Instead, draw the major features, such as overall shape, size and posture. Also be aware that people might object to being drawn without their permission. Please respect their privacy. Draw facial features and likenesses only when your subject has been paid to model or is willing to be drawn.

140
Draw with a pen

Being unable to erase makes you look much more carefully before you make a mark on your paper. Find a pen that helps you make fluid marks and feels very comfortable for drawing people.

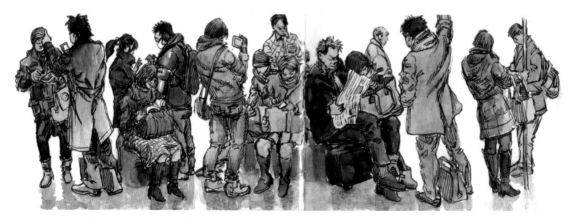

Tokyo Subway Passengers by Russ Stutler (Line and wash); The initial drawing was made on the subway in Tokyo, Japan with a watercolor wash added later. Note how much of the drawing is about the body and the posture and how much is about the face.

141

Drawing posture

Key checks:

- Mark off the top of the head, shoulder line, waist, knees, and end of hands and feet.

- Look for the center of gravity. Drop a virtual plumb line through your drawing of a body and ask: Is it balanced?

- Identify which limbs are tense and which are relaxed.

- Check the angles of limbs relative to the torso.

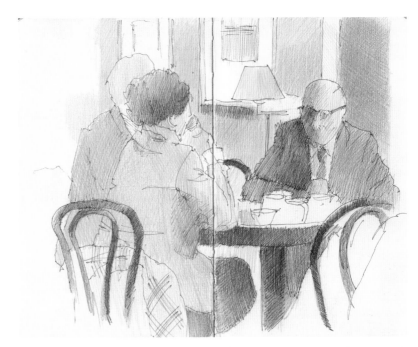

Friends at the RA by Katherine Tyrrell (Pen, ink and colored pencil); Drawn while I drank my cup of tea. Note the emphasis on posture rather than likeness.

142

Use lines to locate people in context

A background can help you draw people. Choose a measurement line from available verticals to help you check proportion and perspective, and then draw people relative to this line. Use lines and edges in the background to help locate people. Frames of windows, doors and paintings are helpful in placing people relative to the context and to each other. This guards against perspective, proportions and angles looking silly and people looking like they're separate from their context.

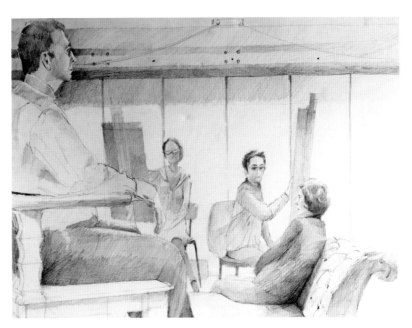

Drawing Class by Katherine Tyrrell (Pencil); I use vertical lines and features within a room (e.g., panels and easels) as an aid for measuring the distance between figures in a drawing class and their relative proportions.

DRAWING THE HEAD

Faces are one of the most enduring subjects for drawing. The selfie has also become one of the popular images in recent times.

Features of an adult head

While no two heads are ever exactly the same, there are basic proportion rules and similarities that can help you to draw one. Look at a head in profile:

- Observe just how small the area is that contains the features that most people focus on, and note that there's a lot going on outside the triangle of eyes and mouth.

- Capture facts (e.g., the angles of the skull and neck) and impressions (e.g., the sense of the hair—you don't need to draw every hair).

- A man's face divides into thirds: Above the brow, from the brow to base of the nose, and from the base of the nose down to the chin.

- The eyes almost always line up with the top of the ears.

- The eyes are halfway between the top of the head and chin.

- The front edge of each ear is about halfway between the front and back of the head.

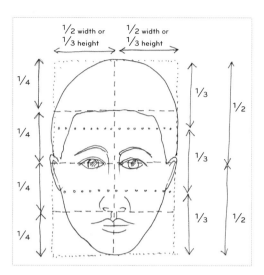

The approximate proportions of the head.

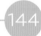

A child's head

The proportions of a child's head are different from an adult's. For example, a child's forehead and eyes are larger, and their nose is typically smaller. When drawing a child, avoid heavy lines. Draw in a light and sensitive way, and avoid overworking details.

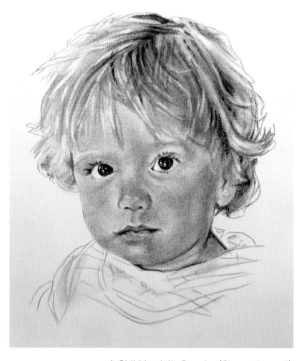

A Child by Julie Douglas (Charcoal pencil);
Note the differences in size of a child's features.
If a child does not look right in a drawing,
check that the proportions are correct.

Benj by John Smolko (Colored pencil); The more mature man has a fuller face, although the features stay in the same place.

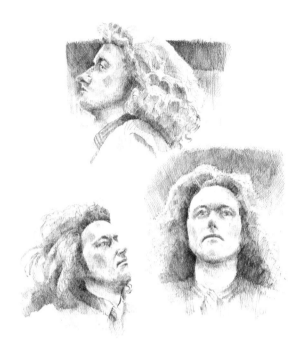

Three Perspectives of Ben by Katherine Tyrrell (Pen and ink); Drawn from life; I moved my chair three times to create this drawing in the two hours available.

145

Draw every aspect

Keep moving round your subject, and look at him or her from different angles. Work on the same paper and leave space for alternative views. This technique works well in a life class, provided you've got room enough to move around without getting in the way of other people.

146

Draw a series of self-portraits

Where better to start when learning how to draw than with your own self-portrait. The big advantage of the self-portrait is that the model always turns up. All you will then need are some mirrors and some interesting lighting...

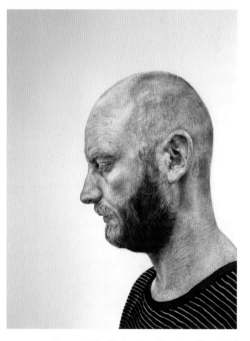

Personal Profile by Alan Coulson (Graphite)

LIFE DRAWING

Life drawing is all about observing and drawing a human body from life (as opposed to drawing from a photograph). Seeing a nude body helps you to learn about anatomical structure and how a body arranges itself in different contexts.

THE BENEFITS OF LIFE DRAWING

Life drawing gives you skills that help you draw any subject. It teaches you:

- How to see.

- Skills in observation and measurement.

- How to draw what you can see.

- How to develop your own style of drawing.

HOW A LIFE CLASS WORKS

You will need to bring your own materials. Most people use charcoal, but you can use whatever you like.

The life class supplies the space, the model, a tutor and easels and/or drawing donkeys. Get to the venue early to get the best views of the model. A typical life class is split into the following sections:

- Very quick 2–3-minute gesture poses to get warmed up.

- One or two poses of 15–20 minutes each.

- The long pose, for which the model often lies down in order to allow careful observation and a drawing of the whole body.

- A review by the tutor of any work done.

The best way to approach a life class is just to draw what you see and not what you think you see.

Develop an ability to draw quickly

Life classes invariably start with quickies to get warmed up. These are very quick drawings (typically 2–5 minutes). Over time and with practice, you will become skilled at selecting what to draw and drawing quickly. One option people now have is to use a digital tablet to develop quickie drawings.

HOW TO DRAW QUICKLY

Do not draw small when starting out. It's much more difficult to draw quickly when working at a small scale. A spiral-bound pad will help you to progress quickly to the next sheet of paper. Focus on getting the whole figure on the paper roughly in proportion. Find the main lines that describe the stance, as well as the middle of the overall shape (it is often near the navel). Use negative shapes of spaces around and within the model to help with sizing and to give context.

Life Drawing Continued by Chrys Allen
(Graphite pencil); Life drawing on a scroll of paper.

Getting the proportions right

Common mistakes are drawings with heads that are too big and feet that are too small. You can practice working out the relative proportions of different parts of the human body by studying photos of human bodies and measuring them. The head is often used as a unit of measurement (see Tip 25).

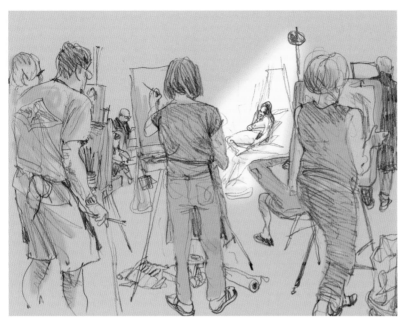

Norfolk Drawing Group (#3) by Walt Taylor (Pencil and digital); The initial drawing was done in pencil, with color added digitally later on.

HOW TO MAKE THE MOST OF A LIFE CLASS

Observation is the key to all life drawing. Look at the model as much as you look at your paper. Relax and don't worry about getting things wrong. Squint to see tone. Use cast shadows to locate a person in space. Measure carefully when drawing the long pose. Speed up your progress by attending life class on a regular basis. You will find your own style in time—don't try to force it.

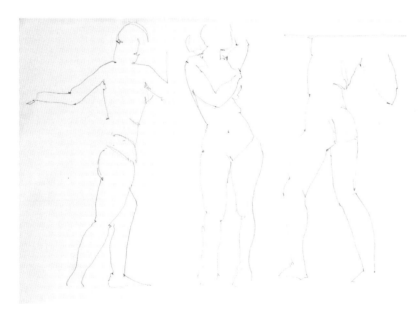

Quickie Sketches in Life Class by Katherine Tyrrell (Pencil); The subjects are often lacking a limb or a head until I've warmed up. The dots at junctions are where I stop and look and think about the next line.

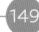

149

Life class models vary from the ideal form

Lots of drawing books reference an idealized shape and size. However, life class models come in all ages, shapes and sizes, and are much more real. Not every model has a shape that conforms to the norm or an ideal shape. Flesh colors and tones vary between the young and old, and the proportions of the male and female form are distinctly different. There aren't a lot of male life models, so if you're lucky enough to get one, focus on the ways in which his shape conforms to and deviates from the ideal.

Foreshortening

Everybody struggles with foreshortening. It causes parts of the body to look implausibly large or small. The accuracy of what you draw is probably correct, but your brain is telling you otherwise. If you want to practice foreshortening, take yourself off to a park on a sunny day and draw people lying on the grass from a safe distance.

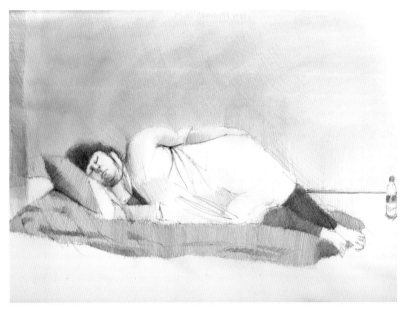

Sue Tilley at the National Portrait Gallery, London, England by Katherine Tyrrell
(Graphite); Sue Tilley is famous as the model for The Benefits Supervisor by Lucian Freud. Life drawing does not always involve nude life models (see also The Clothed Figure on facing page). This sketch was done following an interview with Sue. In the time available, I decided to focus on the big shapes and the tonal values. I used a tissue to smooth out the pencil marks for the rear wall but left the hatching marks more in evidence at the front.

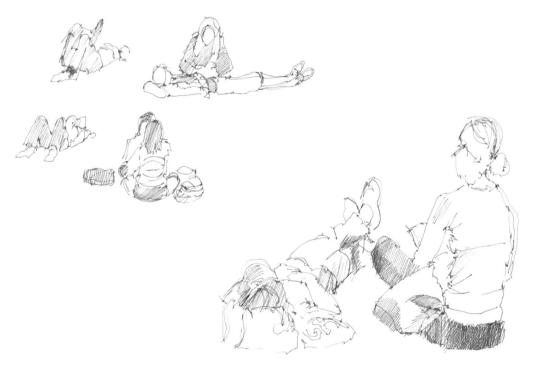

Sketches of People Lying on the Grass Outside Tate Modern, London, England by Katherine Tyrrell
(Pen and ink); Drawing people lying on the grass in the park provides fabulous practice in foreshortening.

THE CLOTHED FIGURE

If drawing the figure is something you love to do it pays to make a special study of clothing. There are a number of excellent books devoted to drawing a clothed figure.

151

Simplify the clothing

You can create very convincing clothed figures even if you simplify the clothing significantly. Pay attention to openings, edges and folds. However, remember that the clothing must reflect the anatomy underneath it.

152

Study the anatomy of folds

It is easy to get lost in the folds of clothing. Stick to these basic rules:

- Draw the big shapes first.
- Identify the lightest light and darkest dark.
- Map the tonal values.
- Define the smaller shapes.

Only after these steps should you make a start on the detail.

153

The drapery challenge

If you like drawing the folds and creases that you see in clothing, why not practice your tonal changes using clothing that is hanging up or laid across a chair?

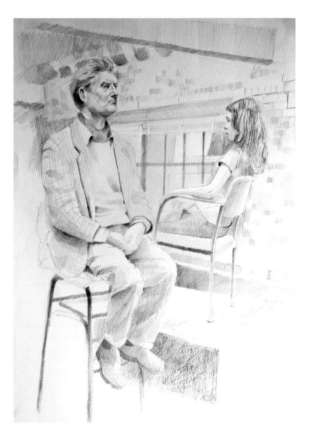

Drapery in the Drawing Class by Katherine Tyrrell *(Graphite); Drawn from life in two hours.*

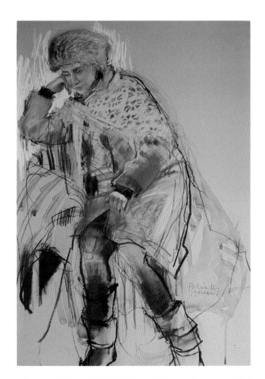

Russian Girl by Felicity House (Charcoal and pastels)

GROUPS OF PEOPLE

I've been drawing groups of people for years. This is what I've learned.

154

Ice Skating at the Natural History Museum Rink, London, England by Katherine Tyrrell (Colored pencil); This scene shows constant movement.

People keep moving, so learn to draw fast

Accept that when drawing groups of people, they will often move before you've finished. Strategies for dealing with this include:

- Accept you'll have pieces that are never finished.

- Learn to draw faster so you record more before they move.

- Stick to big shapes except around the head.

- Posture is more important than clothes.

- Learn how to substitute—include people who arrived and left at different times. Match up the top half of one person with the bottom half of another.

- Look for people who are static or who make repetitive movements.

155

Map out the contour first

Map the contour of the shape of a group of people before you start to separate them out into individuals. For example, people sitting around a table can be captured initially as a few big shapes.

PLACES WHERE YOU CAN DRAW GROUPS OF PEOPLE

As you grow in confidence, start to draw groups of people. Visit places where people may stay still but also move around and come and go:

- Cafés and restaurants

- Bars and drinking places

- Festivals

- Sports events

- Parks and gardens

- Museums and art galleries

- Waiting rooms and queues

- Streets and public transportation

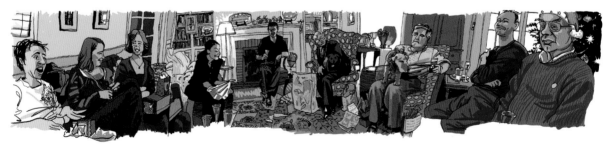

Christmas Gathering by Walt Taylor (Digital drawing using Corel Painter); The great thing about app drawing is that you can extend the format beyond the conventional.

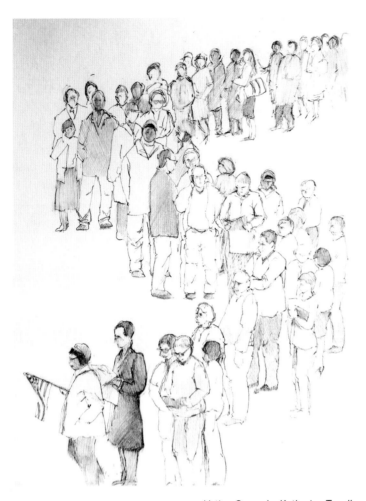

How to create a composite drawing of a group

- Use individual images from a variety of different sources to create a composite drawing that has a narrative but lacks the context provided by location.

- Remember that it is normal for people standing in the same place to be different heights. Perspective comes into play when people are at different distances from you.

- Work out how to overlap people (and make sure you do).

- Make adjustments to keep them in proportion as they recede into the background.

- Aim for plausibility rather than spot-on accuracy.

- You may find you create composite people, but it's not a portrait, so that doesn't matter.

- Note that it's sometimes easier to draw large groups of people if you're looking down from above.

Voting Queue by Katherine Tyrrell
(Pencil); While waiting for the result of the 2008 elections in the USA to be declared I created this composite drawing of voters from the very many online images of people queuing to vote. The process was akin to a piecing together a jigsaw puzzle.

Exhibition Visitors by Katherine Tyrrell (Pen and ink); Contour overlap drawing of visitors to an exhibition. I kept looking for where the head was relative to the top of a frame to gauge placement and size.

THE NATURAL WORLD

DOMESTIC ANIMALS

Most people who draw domestic animals start with the head. In terms of realism, skill in the drawing of eyes and fur is what separates out the serious animal artist from the amateur.

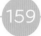

How to draw eyes

It's best to complete each stage for both eyes at the same time:

1. Study the shape and color of the eye.

2. Outline the eye and indicate the shape of the pupil.

3. Reserve the highlight on the pupils, which will add life to the drawing of any animal.

4. Color both iris and pupil—note these are not flat areas of color.

5. Color the iris with thin glazing washes of more than one color, indicating any streaks of coloration.

6. Reinforce the outer edge of the iris; the stronger color helps give form to the spherical eyeball.

7. Darken the outer edge of the eye.

8. Finish with the shadow on the eye created by the eyelid.

—Courtesy of Gayle Mason

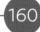

How to draw whiskers

Use an indenting tool to capture whiskers or fine hairs (see Indenting Tools, page 161). Very smooth paper is the best surface for precision drawing of fur, feathers or whiskers.

Drawing dogs

Dogs vary in shape as much as people. Observation and understanding of a breed of dog is the only way to draw with truth. Gun dogs, working dogs and agility dogs all provide many opportunities to practise sketching dogs on the move or at work.

From domestic to big cats

Many aspects of domestic cats are very similar to the big cats. The latter are just on a much larger scale. So if you want to draw big cats, the best approach is to develop and practice your skills drawing domestic cats first.

Lenny by Gayle Mason (Colored pencil);
This illustrates the pattern of fur growth and the importance of capturing the guard hairs. Gayle uses this sketch as a teaching tool to demonstrate how to build up black using a variety of blues and also how to indent "status" hairs.

Draw animals with symmetrical faces

Start with the eyes and get the shape and position of these right first. Complete the eyes. Next work outwards from the eyes and make sure the planes of the eyes, nose and base of ears all line up no matter what angle the dog has its head. Mistakes in symmetry tend to be very obvious.

162

How to draw fur

"How do you draw fur?" is one of the most frequent questions asked of animal artists.

1. Learn about the character of the fur you will be drawing (fur has a lot of different textures—fine, soft, stiff, thick, harsh and so on). Try feeling the fur before you start.

2. Focus on the overall shape and form of the animal. It's no good being precise on the fur if the form is wrong.

3. Don't start on detail until you've worked out the big shapes and tones.

4. Simplify and map the tonal pattern into no more than five tones to help develop form and provide a base for the later drawing and shading of the fur.

5. The fur pattern on the face is complex. Create a fur map from observation to aid your mark-making. Look at how the fur follows the underlying form and make sure strokes follow the direction in which the hairs grow.

6. Fur is rarely one color. Demonstrating variation in fur is essential for both color and monochrome drawings. Look at individual hairs to understand how color varies.

7. Hairs in fur are indicated by drawing the positive (i.e., hair) and the negative (i.e., space around the hair).

8. Use a pointed eraser to lift out hair from a dark tone.

—Courtesy of Gayle Mason

A Fur Map by Gayle Mason (Pencil); The arrows indicate the direction of fur growth and therefore the direction that any drawn hairs need to follow.

Pick of the Litter by Katherine Tyrrell (Colored pencil); When providing a background, make sure it adds value.

Poppy by Gayle Mason (Colored pencil); Check the eyes against Gayle's tips for drawing eyes (see Tip 157).

How to tackle pet commissions

There are more than a few people making a living from drawing commissioned portraits of pets. Here are some guidelines if you'd like to try this work yourself:

- Do not work from a poor reference photograph; give clients guidance as to what you require.

- The best reference photos are the ones you take yourself using a high-quality camera. Take shots of key areas such as the face.

- Charge for any photography and travel costs, or make provision within the commission fee.

- Before you start work you need to agree the terms of business in writing and collect a deposit.

- Work on the basis of stage payments, with an initial payment on commission and the remainder paid on completion or delivery.

- Send the client a low-resolution copy of a near-finished drawing for comment before you complete the work.

- Retain the copyright for prints.

- Deliver in a mat cut to the preferred frame size.

- Advise the client on framing or arrange for the work to be custom-framed (the full cost should be charged to the client).

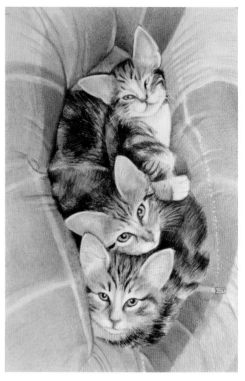

Meet the Kittens by Katherine Tyrrell (Colored pencil); This was featured on the front of the Society of Feline Artists' annual exhibition brochure.

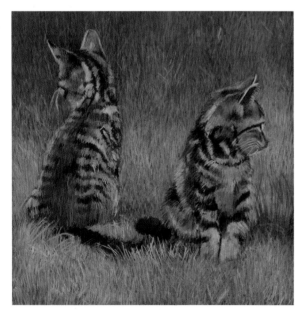

Eyes Left by Katherine Tyrrell (Colored pencil); Dead space between the two kittens in the reference photos was eliminated to create a more interesting composition.

Composite drawing from different references

It is not uncommon for artists to want to work from photographs when drawing animals because the subject is apt to refuse to sit still and pose. Select reference material from different photos. Feel free to move subjects around to make a better composition, but be sure to retain perspective and proportion and keep the lighting consistent.

WILDLIFE

The tips and techniques in this section can be applied to any wildlife, although most of the examples relate to birds. Drawings and paintings of wildlife generally—and birds in particular—are very popular, especially with art collectors.

HOW TO SEE WILDLIFE

Understanding the form and movement of an animal comes from repeated observation, and there are several ways to get the most from your research.

Animals and birds tend to move around rather than pose for people who want to draw them.

It's best to:

- Practice drawing quickly. Emphasize drawing from the general to the particular.

- Consider ways you can get a better look.

- Take your own reference photos.

- Keep a field sketchbook.

- Don't worry if you have a lot of false starts.

165

Practice drawing animals and birds

A natural history museum is typically full of stuffed or preserved animals that don't move. This will give you the opportunity to build on your experience—assessing scale and proportion plus looking at features up close—before trying to sketch live animals.

Specimen Butterflies by Katherine Tyrrell
(Pen, sepia ink and colored pencil)

166

Observe wildlife using webcams

Preview the challenges of observing live wildlife through the use of wildlife webcams (e.g., wildlifetrusts.org/webcams). Webcams are also ideal for those artists who want to observe and draw from life but have problems accessing areas where they could do this in person.

Sketch of a (Stuffed) Dodo, Natural History Museum, London, England by Katherine Tyrrell (Pen and sepia ink); My first sketch was truly awful—this is the third one.

WHERE TO FIND WILDLIFE

Once you've mastered basic drawing skills you can do field drawings of wildlife in its natural habitat. This could include:

- Birds and other wildlife in your garden

- Farm animals

- Wildlife reservations

- Zoos

- Sanctuaries dedicated to protecting a species

- The countryside

View but don't disturb

Professional wildlife artists use a telescope or binoculars to view a subject without disturbing it. Your sketches of behavior will be more accurate as a result.

168

Invest in a good camera or camcorder

Use a good zoom lens plus a mechanism such as a tripod to absorb shake. Videos are best for providing information about movement.

169

Keep it simple

If you want to draw animals, the basic rule is that you should observe much and long, and draw fast and little. Collect enough information to create a more detailed drawing later.

170

Keep a wildlife sketchbook

Your skill and judgment—and confidence—will improve significantly if you keep a field sketchbook. You can also practice drawing wildlife using reference photos or webcams, allowing you to find ways of simplifying mark-making in the field. Create your own shorthand for use in the field to record animals or birds in different positions and as part of a group.

171

Draw found objects

Natural history artists also draw found still life objects related to animals, such as feathers, eggs and nests. Items like feathers can also be drawn at leisure back in the studio.

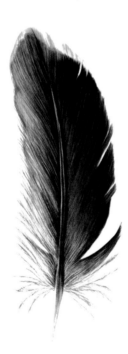

Mallard Feather by Sarah Morrish (Acrylic ink)

172

How to draw birds

- First, spend time observing your subject, identifying its typical postures and gestures.

- Warm up by quickly drawing the most relevant shapes.

- Photograph or video reference material to study later.

- Draw from the general to the particular.

- Focus initially on the core shape of the bird.

- Start off with big, simple geometric shapes and then progress to the contours and smaller shapes before moving finally onto the details.

- Note any colors observed (with date).

- Do small studies of movement and posture, such as how the bird holds and moves its head.

- If standing, watch how the bird stays balanced; locate its center of gravity.

- Assess the angle of beak, body and legs relative to the head.

- Indicate their positions using straight and curved lines.

- Observe and identify the substructures in plumage.

- Indicate the colors.

- Refine the drawing, if you have time.

- Once you're back home, check the shapes, structure and plumage details against your reference photos.

—Courtesy of Tim Wootton SWLA; author of *Drawing and Painting Birds*.

Waxwings by Tim Wootton (Marker pen and watercolor); Tim uses a Sharpie marker pen to outline twigs and birds before adding watercolor.

Sketches of Waxwings by Tim Wootton (Pencil and watercolor); More developed drawings start off as quick sketches noting posture and color.

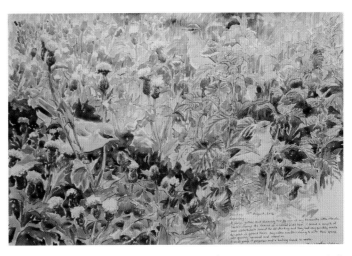

Nest by Alan Woollett (Colored pencil)

A Sting in the Tale by Tim Wootton (Conté crayon and watercolor); Created during a field study to Copinsay in the Orkney Islands in Scotland. It portrays a Lesser White Throat defending its patch of ground from a couple of Willow Warblers. Conté is used for drawing and watercolor provides the impact through the use of complementary colors.

PLANTS AND FLOWERS

Botanical artists frequently draw from observation and not from photographs. They typically start their observation in the field and then continue to draw from live specimens when they get back to their studio. They will also draw a plant through the seasons, at every stage of growth and decay.

173

Keep a nature sketchbook

A field sketchbook is an invaluable piece of kit for people interested in drawing plants and flowers. It is particularly useful if the plant must stay in its habitat and has to be drawn *in situ*. Use your sketchbook to:

- Note measurements (e.g., flowers, buds and leaves); record the growth habit over time.

- Make notes about habitat.

- Record details of structures that reference photos might miss.

- Produce color studies and notes about any observed colors.

Spring: Prelude by Katherine Tyrrell (Colored pencil); A drawing of allium in bud.

Working Sketch of Philesia Magellanica by Işik Güner (Pencil and watercolor); This sketch isolates and details the structure of the plant and notes the color mixes to be used in the final painting. Işik's other work for this project won her a gold medal and the best picture in show at the Royal Horticultural Society Botanical Art Show in 2014. Sketches such as this are how it all starts.

174

Color mix references

Before you start to draw, identify colors and color mixes relevant to each individual plant, flower and leaf. A set of color mixing and shade cards for plants provides guidance on which mixes will produce the right color and can be used in the field.

175

Spring: Draw new life

Focus on the structures of new growth, blossom and spring flowers and the very particular fresh greens of new leaves.

176

Summer: Draw full blooms

In summer, the challenge is the abundance of subject matter in terms of both flowers and fruit. Focus a series of drawings on themes around color, plant families or habitat.

Summer: Oriental Poppies by Ann Swan (Colored pencil); This shows the stages from bud to full bloom.

Fall: Horse Chestnuts in Autumn by Sigrid Frensen (Colored pencil)

177

Fall: Draw fruits, leaves and seeds

Fall brings the changing colors of leaves and the production of nuts, seeds, orchard fruit and root vegetables.

178

Winter: Draw life in a dormant season

Winter gardens have less choice in terms of flowers but do offer other interesting subject matter—for example, pine cones, lichens, winter vegetables and the structure of leafless trees.

Winter: Snowdrops and Cyclamen by Susan Christopher-Coulson (Colored pencil); Part of a series of winter-flowering bulbs.

179

Plan and prioritize your drawing

It may sound obvious, but it's essential to prioritize when drawing from life. Take reference photographs of the setup and prepare color studies. Start with the parts of the plant that are likely to wither or die first.

Calamondin by Shevaun Doherty (Watercolor); Drawings on tracing paper are used to determine whether to add more fruit to this watercolor painting.

184

Draw to scale

Draw subjects at life size and it becomes easier to adjust size to scale at a later stage. Decide on a unit of scale at the outset, e.g., 1in. and use that as a baseline for measuring your material. Proportional dividers (see page 157) and a photocopier can both assist with scaling up and down.

180

Keep plants and flowers fresh for drawing

Keep material cool to arrest development as this will give you more time to draw your subject—placing plant life and flowers in the fridge at night will help with this. Keep material moist and use floral foam or wrap the stems in a damp cloth or paper. Use plastic bags with closures for specimens found in the field.

182

Strict rules on shading

Botanical illustration eliminates context detail and shading outside the positive shape of the flower or plant.

183

Use tracing paper to develop a composition

Decide what plant components you want to include, then draw each of them on separate sheets of tracing paper. Overlay and reposition the tracings on a flat surface until you find your preferred composition. Finally, tape down with low-tack tape and then make a master tracing for the final piece.

185

Keep paper clean

Keep paper clean by protecting the parts of the drawing already completed—for example, by taping down tracing paper or glassine.

181

How to set up and hold plant life

Tips include:

- Use a laboratory retort stand and clamp to hold a specimen in place.
- Place specimens in a good light to see their details—natural light is best.
- Avoid heating the plant if using artificial light.
- Keep your studio cool to limit the development of blooms.
- Neutralize the background color to avoid reflections.
- Attach individual petals and leaves to a board using double-sided sticky tape if you want to study them flat.

This setup, created by Sharon Tingey, uses a clamp for drawing from life alongside reference photos and studies.

Bishop Pine Cone: Pinus Muricata by Sharon Tingey (Pencil)

Nymphaea Thermarum by Lucy T Smith (Pen and ink);
*A technical botanical illustration. Note the careful arrangement of
images of different parts of the plant, including dissections.*

*"I would rather teach drawing that my pupils may
learn to love nature, than teach the looking at nature
that they may learn to draw."*
—John Ruskin (1819–1900)

Honeybells by Sigrid Frensen (Colored pencil); A drawing of the
growth stages of honeybells (Nectaroscordum siculum). The life
cycle is a favorite subject of artists concerned with nature.

Uprooted 1 by Liz Charsley-Jory (Acrylic inks); Plant drawings
often adopt a "top to toe" approach and incorporate everything
that shows the growth habit—including the roots.

DRAWING PLACES: INTERIORS

To build your confidence, start from your own home and then venture out.

HOMES AND ROOMS WITH A VIEW

186

Draw your own home

For beginners, or for people coming back to drawing after a long period, drawing the interior of your own home is a really good place to start. But it's useful to remember that it doesn't have to be perfect.

A Corner of My Home by Katherine Tyrrell (Pencil); Try drawing light as it comes through a window, and also draw its impact on forms and shapes.

Kitchen Window by Laura Frankstone (Pencil and watercolor); Laura draws the "found" interior of her home.

187

Start with a corner of your home

Home is a great place for exploring various aspects of the tips and techniques featured in this book. Start small—try drawing just a corner of a room—and explore specific aspects such as:

- Drawing shapes.
- Studying light effects on color and tone.
- Creating 3-D on 2-D through variation of tonal values.
- Practicing perspective drawing.
- Creating background contexts for objects.

188

Draw your room "as found"

Make it your home, not a show home. Draw it as you see it, even if the bed is unmade or your cat is sleeping on one of the chairs. Draw your room when you stay away from home.

189

Draw the room and the view

The room with a view is a classic subject for artists. However, it's tricky getting the balance right between the tone and color of the interior wall and the external scene. Try drawing a room with a great view.

In a Watercolor Bath by Laura Frankstone (Watercolor);
Note the use of a resist to create the swirls in the water.

Chloe's Chair by Katherine Tyrrell
(Pen and sepia ink); Drawing upholstery,
cushions and curtains is rather like drawing
clothing; there's a lot of folds and drapes.

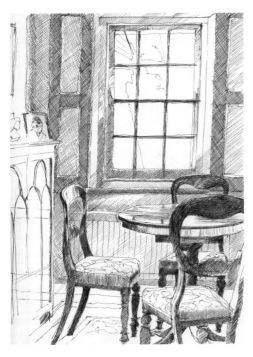

Traditional Wax by Katherine Tyrrell
(Pen and ink); This drawing focuses on
tonal range against backlighting.

Interior of Ananda Cottages in Ubud, Bali, Indonesia by Katherine Tyrrell
(Pencil); There's no glass in the windows, and I wanted a memory
of that and the dense vegetation just outside them.

CAFÉS AND RESTAURANTS

This is my favorite occupation. I sketch the interiors, I sketch the people and I sketch the food. What's not to like?

190

Say you want to draw

Ask if you can draw in the café or restaurant. If you're a paying customer, it shouldn't be a problem. Sit where you can see the interior and people at the tables, and don't be surprised if waiters show an interest in what you're doing.

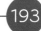

Breakfast at the Big Sky Café in San Luis Obispo by Katherine Tyrrell (Pen, ink and colored pencil); Halfway through my drive down Highway 1 from San Francisco to San Diego, USA.

191

Draw the food and drink

This is the best ever tip for anybody traveling on their own. It passes the time, and you also get a record of all the different meals you ate.

192

Have a break from your work

Create time for sketching in your working day. Work out how to combine a physical break from work with the mental break offered by making a short sketch. I learned the value of sketching when my work took me all over the UK. Sketching at mealtimes is a great way of passing the time while eating alone and having a complete break from the working day.

193

Draw new places on a road trip

A couple of very long road trips in the US taught me about the diverse and interesting opportunities that places to eat offer for drawing within a limited timeframe. I also learned to sketch very fast while eating.

Chinese New Year in Wimbledon, England by Jhih-Ren Shih (Pin pen and watercolor)

Brunch at St. John's Spitalfields, London, England by Katherine Tyrrell (Pen, ink and colored pencil);
I sketched people as they came and went—they were never all there at the same time. I loved the
challenge of the different shapes, lighting and finding the colors in all the white walls.

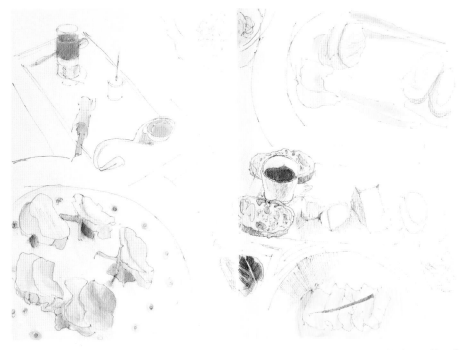

Lunch at La Maison Jaune, St. Remy de Provence, France by Katherine Tyrrell
(Pen, ink and colored pencil); Try starting a drawing where you have no idea what
your subject will look like. I start top left and work through the courses to bottom right.

ART GALLERIES AND MUSEUMS

Copying artwork is a great way to learn more about art. This section looks at what you typically can and can't do when drawing in a museum, and gives a few ideas on what to draw.

Sketch of Students Drawing in the National Gallery, London, England by Jhih-Ren Shih (Pencil and watercolor); Watercolor was added at home.

194

Check the art media allowed

If you don't want to be shown the door, check what media can be used. Lots of art galleries and museums allow drawing with dry media. Galleries that have valuable art collections tend not to allow any wet or messy media, such as watercolor and charcoal, inside the gallery without prior written permission.

- Pencils and pens using cartridges are typically fine.
- Colored pencils work particularly well if you want to capture color. Digital tablets should also be fine.

Monet's Painting of Antibes, Courtauld Gallery, London, England by Katherine Tyrrell (Pencil and colored pencil); This was completed in the gallery.

195

Check the availability of sketching stools

Many art galleries and museums make sketching stools available for people who visit to draw and sketch the artwork. The front desk can tell you where these are kept.

196

Choose a sensible place to sit

Avoid obstructing the flow of visitors in the galleries. Sit with your back to a wall or in a corner to avoid becoming the center of attention or people peering over your shoulder.

Richard Parkes Bonington's Painting of Venice, Wallace Collection, London, England by Katherine Tyrrell (Pen, ink and colored pencil)

197

What to draw in an art gallery

- A painting: learn about how other people construct drawings and paintings.
- A sculpture or large 3-D objects
- The gallery as an interior space itself.
- The flow of people through the gallery.
- A collection of items in the gallery.

Don't draw the security staff without asking permission.

After John Constable—Boat Building Near Flatford Mill by Katherine Tyrrell
(Pen, sepia ink and colored pencil)

198

Choose a theme and assemble a collection of drawings

One way of tackling the variety of subject matter within a museum is to choose a theme and then develop a set of drawings around the theme. You could develop a set of individual drawings or one single large drawing that comprises several smaller items.

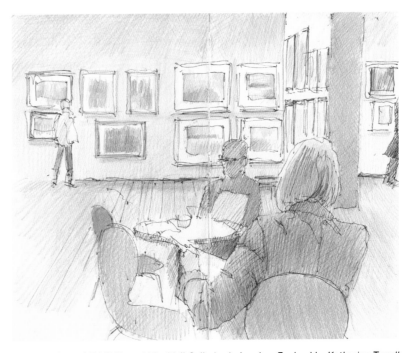

199

Sketch people viewing paintings

People come and go all the time in galleries, but some stand and stare at the paintings. You can create a composite drawing of people in a gallery if you work quickly.

Annual Exhibition at The Mall Galleries in London, England by Katherine Tyrrell
(Pen, ink and colored pencil); It's fascinating doing thumbnail sketches of real paintings viewed from a distance.

QUEUES AND WAITING ROOMS

Sketching is an excellent way of whiling away the time in a place where it's likely you'll be stuck in a queue. The sketches on this page tell the story of my visit to hospital for an eye operation and the follow-up appointment.

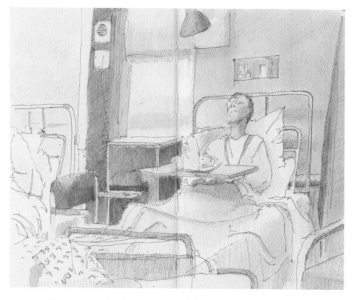

Hospital Sketch 1 by Katherine Tyrrell (Pen, sepia ink and colored pencil); Sketching the ward while waiting to go to the operating room.

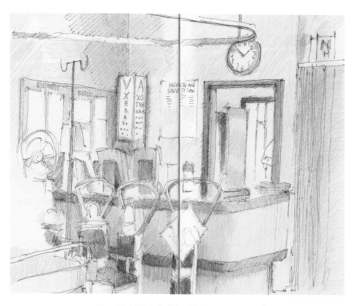

Hospital Sketch 2 by Katherine Tyrrell (Pen, sepia ink and colored pencil); Two hours later, still waiting—and the eye charts and oxygen tanks start to look really interesting.

Waiting = sketchbook

Always take a sketchbook if your day is likely to involve a waiting room.

Sketch the context

You have the time to make a study of the context. This is when you start drawing the oddest items.

Sketch the middle distance

Choose people in the middle distance. If you focus on form rather than likeness, there will no embarrassment. You can also draw bodies without having to go to life class.

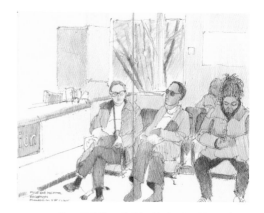

Hospital Sketch 3 by Katherine Tyrrell (Pen, sepia ink and colored pencil); Four weeks later, in the outpatient waiting room.

TRAVEL

Sketches made while traveling not only pass the time but also allow you time to practice your drawing skills.

Draw people on trains, planes and buses

People who are traveling make good subjects for quick sketches. It works best if you draw somebody in the middle distance rather than directly opposite you.

Match your media to your situation

The type of media you can use is very much dictated by the type of vehicle you are traveling in. Many people opt for pencils or pen and ink. Watercolor pencils and water brushes are also popular as they are quite portable.

Draw in the car

I've drawn the driver, the view out the front window and the view out the side window. The latter provides material for a composite sketch.

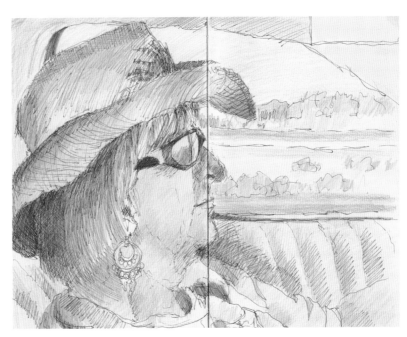

Louise drives the desert in style, USA by Katherine Tyrrell (Colored pencil); My sketch notes the temperature outside was 118°F (48°C) on the last leg of our 2,000-mile road trip.

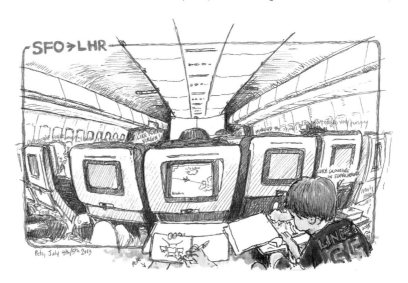

SFO to LHR by Peter Scully (Pen, ink and watercolor); Pete Scully goes beyond the normal perspective drawing of an airplane interior and backs of seats. He also includes his own hand and his son, who is coloring in the super heroes outlines drawn by Pete to keep him occupied on the trip. The piece is contained within a frame with a flexible border.

DRAWING PLACES: EXTERIORS

Drawing outside generates a number of challenges, the most significant of which is perhaps that the environment changes as you draw.

206

Location: Do your homework

If you have limited time, check out potential locations in advance. On a sketchcrawl, or drawing as part of a group, locate a friendly café or spot to meet up in advance and at the end. Locate the facilities before you need them.

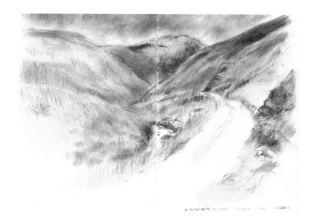

Shilmoor, Northumberland, England by Vivien Blackburn (Charcoal); Tinted charcoal was used for this sketch of a very chilly Northumbria.

A Crisp, Clear Morning With Frost by Katherine Tyrrell (Colored pencil); This is an example of the glowing light in the golden hour.

207

Travel light

Only take what you need. If traveling abroad, reduce the weight of your sketching kit to the essentials and pack it in your carry-on bag.

208

Find the sunlight and shade

The "golden hour" occurs when the sun is low in the sky—at the beginning and end of the day—or in the winter months. This is the best time for interesting light and shadows, although they move very fast. It's much easier to evaluate both color and tones if you keep your work out of the sun. You'll also see much more clearly wearing a brimmed hat or visor that keeps the light out of your eyes.

209

Stay healthy and safe

Make sure you have water—it's easy to become dehydrated when absorbed in sketching. Wear sunscreen and avoid "sketcher sunburn." Your core body temperature can also drop significantly if you stay still in cold weather, so wear thermal underwear and a hat when it's cold. If sketching in a lonely spot, sit somewhere you can't be approached from behind, and don't go solo into the wilds without telling somebody where you're going.

210

Maintain circulation

It's important to maintain your circulation. Don't stand motionless for too long on one spot, and avoid sitting for too long on a small stool. Take regular breaks, stretch and walk around periodically. Rotate your arms to loosen up and get the blood moving.

BUILDINGS AND STREETSCAPES

A lot of urban sketchers who produce great drawings of buildings and streetscapes are people who work in or are studying architecture or illustration. However, other people can also create good drawings of buildings. If you want to be very precise, it's certainly worth taking time out to study perspective drawing in detail. However, be aware that it's complex and technical.

Key principles for drawing buildings

Before you start, review the section on perspective (pages 32–33). When you choose a viewing position, pick a spot that offers an interesting perspective of the building. Observe how light and shade describe the shapes and angles and differentiate between big shapes and detail. Describe buildings in terms of big shapes and block these forms first, and remember: lines at the eyeline are always horizontal. Practice assessing the angles of lines above and below the eyeline and drawing lines that converge on the vanishing point.

Rooflines

Don't forget to look up at rooflines. Older buildings can often display really interesting shapes and decorative features (see Felicity's sketches on this page). Pay particular attention to the angles and length of lines.

HOW TO DRAW BUILDINGS WITHOUT PERSPECTIVE

This is a tried and tested way of sketching architecture in its context:

1. Choose an interesting building to draw.

2. Identify the big shape you want to focus on initially.

3. Work out the major divisions in the structure in terms of verticals and horizontals (e.g., the roof, different floors, windows, doors).

4. Plan out where these lie before you start to draw lines (I use dots to start with to indicate where I think lines should be).

5. Check the proportions of one part of the structure to the whole. For example, is the fact that the floors get narrower as you go up the building a design feature, or is it because you're squeezing them into the space you've got left?

6. Make sure lines and edges within the building have adequate thickness but are not too thick.

7. Have fun with the detail.

—Courtesy of Liz Steel

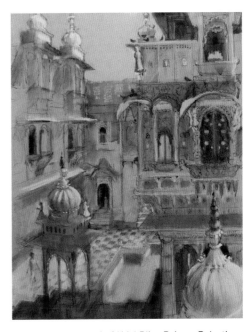

Courtyard of Udai Bilas Palace, Rajasthan, India by Felicity House (Pastel)

Palace sketches by Felicity House (Watercolor); A good test of whether you've learned how to draw buildings is to tackle a form of architecture that is unfamiliar.

Study doors and windows

Thomas Corrie spent a month drawing doors all over London. Similarly, you could make a study of doors and windows—you'll learn a lot. Consider the following questions:

- Is the door or window inset (i.e., set back) or flush with the front of the wall?

- What type of molding or architrave provides a frame?

- How thick are the verticals and horizontals?

- How do the shadows and reflections work in terms of tone and angle?

- Is the shape irregular in any way at all?

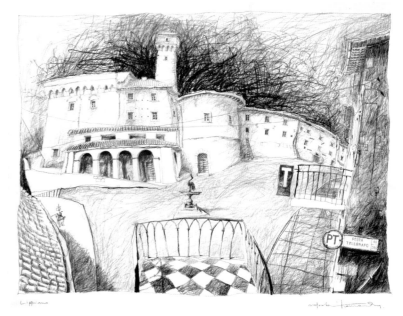

Lippiano, Umbria, Italy by Mat Barber Kennedy (Graphite);
This drawing blends deliberate control and spontaneous energy.

People that street!

Learn how to populate streetscapes with people. Use photos to practice drawing people in the street quickly. Note the relative proportions of body parts and think about how you can indicate posture and momentum. Identify the details that help differentiate an individual from others around them.

When confident, position yourself against the light and look at shapes you can see (an example is my Pescheria drawing on the opposite page). Avoid detail and draw postures of people standing or sitting, and the shapes of people walking.

The Surviving Pedimented House From the Adams Brothers' Adephi Project by Thomas Corrie (Pen and ink)

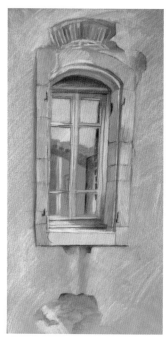

French Window by Katherine Tyrrell (Colored pencil); This sketch of a window—drawn from a window across the street—reveals the underlying structure of the building.

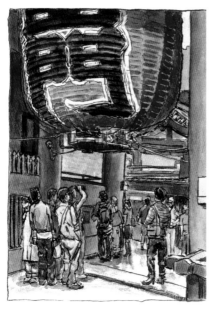

Kaminarimon in Asakusa, Japan by Russ Stutler
(Pen, ink and watercolor); Sketching involves
dodging the tourists to draw the tourists

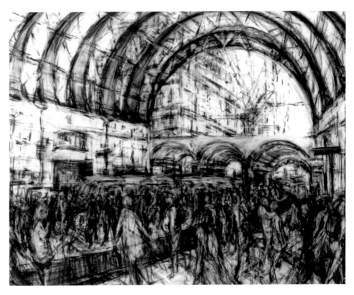

Rush Hour Crowds and Trains Moving Inside Canary
Wharf, London, England by Jeanette Barnes (Charcoal)

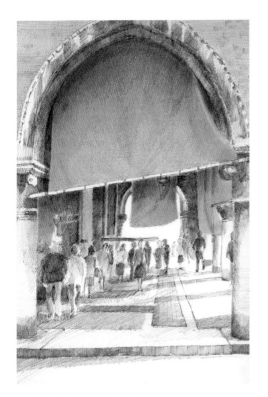

Drawing of the Pescheria (Fish Market) in Venice,
Italy by Katherine Tyrrell (Pen, ink and colored
pencil); Note shapes of people against the
light and lots of hatched shadows.

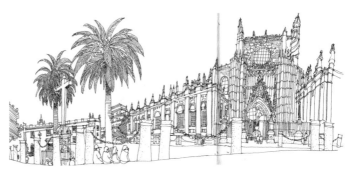

Cathedrale y Giraldo in Seville, Spain by Teoh Yi Chie (Pen and ink);
This drawing has a wonderful top line, and the sense of scale is
helped by the people sitting on the wall in the foreground.

LANDSCAPES

215

How to approach a *plein air* landscape

There is nothing more frustrating than not finishing. If working *en plein air*, you need to work out an appropriate approach within the time available to ensure you are able to finish the drawing.

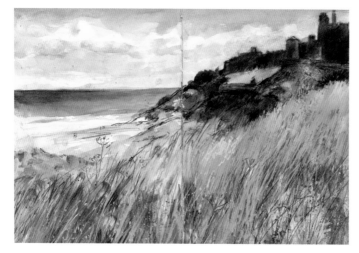

Bamburgh Castle, Northumberland, England by Vivien Blackburn (Watercolor, charcoal, pastel, biro, Conté pencil, gouache and white ink); The castle and beach in this plein air *sketch are located in the middle ground—with grass in the foreground and the sea in the background.*

ALTERNATIVE APPROACHES TO DRAWING *EN PLEIN AIR*

- Draw the same view throughout the year in different seasons, at different times of day and in different ways.

- Revisit a location to develop the same or additional drawings.

- When drawing in places you are unlikely to visit again, collect reference material. Take photos and do lots of thumbnails, sketches and color studies. Develop a drawing on returning home.

- Choose a size, format and style according to the time available so as to give yourself a reasonable prospect of finishing the drawing without rushing.

216

Think in zones

This is a very useful tip that really does help when thinking about composition. Look at the space and work out how to split it into different zones. These include the foreground, middle ground and background.

217

The horizon line

Where you place your horizon line needs to be decided early on as it influences both the perspective and the emotional impact of a drawing. Look also for horizontal lines that echo the horizon.

218

Avoid symmetry and even numbers

Try to avoid positioning the horizon line so that it slices the drawing into two equal halves. Also avoid even numbers when drawing important objects, such as trees, buildings and clouds.

219

The big view

If you like a challenge, try getting to grips with drawing a big view. Various scenes qualify for the term "big view," including: The view looking down from a high point such as from the top of a hill; the view looking up at tall objects, such as buildings and mountains; and a long, lateral view, such as buildings along a river. When considering these views, think about which format and media will be suitable.

220

Differentiate key zones

The key zones are the background, middle ground and foreground.

- Identify any tonal and color differences between the zones.

- Think of the background as part of the whole rather than treating it as an afterthought.

- Focus on mastering techniques for creating depth and recession (see Space, pages 30–31). For example, overlapping shapes in the middle ground will create an impression of distance and recession.

- Remember that the level of detail described should recede as the eye moves through the zones.

- Avoid a "fringe effect" in the foreground that acts as a barrier to the eye entering the picture.

- Think about ways to lead the eye around the drawing.

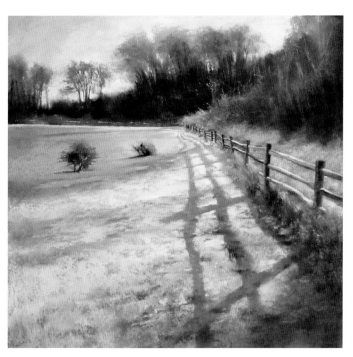

Heartbreak Morning by Barbara Newton (Pastel); *This pastel has a clear foreground, middle ground and background, plus offers a clear a way into the scene.*

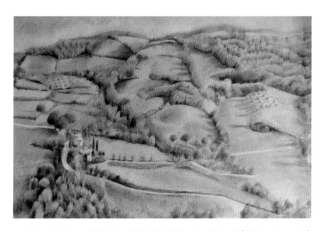

Wynn's View of Umbria, Italy by Katherine Tyrrell (Colored pencil); *This was an exercise in working out patterns of light and shadows among the hills and trees. I achieved an aerial perspective by drawing this from a roof terrace.*

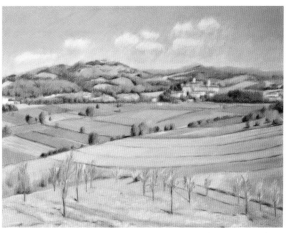

Monterchi, Valtiberina, Italy by Katherine Tyrrell (Colored pencil); *The triangular shape in the foreground leads the eye in and echoes the shapes of the Tuscan hills in the background. The zones are also differentiated with color.*

TREES AND VEGETATION

If you want to learn how to draw trees I have two quick tips: Accept there is no single quick-fix approach to drawing them and learn how to draw them one by one.

Two Sisters by Loriann Signori (Pastel); As seen in Manassas National Battlefield Park, Virginia, USA.

221

Location, climate and season all affect color

The color palette of trees is affected by numerous things, including climate and season. Location is also fundamental to the way you will perceive trees' color—the quality and nature of light in the place where you are drawing will fundamentally alter the color palette.

HOW TO RECORD COLORS

Every time you draw an unfamiliar tree, study it and count all the different colors you can see. In your sketchbook, create a color chart for that tree specific to the location and the time of year.

Dark Skies Above the Orchard by Reuven Dattner (Pen, ink and watercolor); Reuven has a talent for simplifying and articulating patterns.

222

Learn about trees

Observe and get to know trees in order to be able to draw them effectively. If you like trees a lot and want to learn how to draw them, I suggest you start by taking some time out to look at and learn about them. Look at their anatomy and structure—for example, study the way their branches articulate from the trunk—and find out how they grow and change through the seasons. Study the way they look from a range of different perspectives.

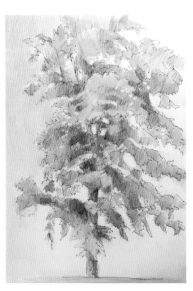

Study of a Tree in a Park, by Katherine Tyrrell (Pen, ink and colored pencil); This focuses on the birdie holes.

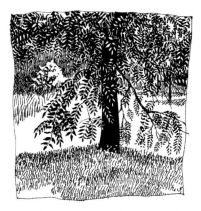

Ann's Tree by Walt Taylor (Pen and ink); A very simple and effective example of how monochrome mark-making can render a tree.

Draw trees repeatedly at all times of year

It is easier to understand the shape of a tree in winter when, because it has lost its leaves, its underlying structure is evident. Draw the pattern of branches and how they radiate out from the trunk of the tree.

Draw trees from a distance

To help you capture the shape of an unfamiliar tree, try drawing it from a distance. Good places to do this are parks or the countryside.

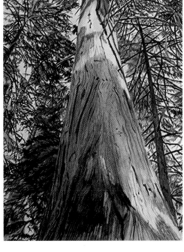

Nuu Chah Nulth Trail, Tofino, British Columbia, Canada by Liz Charsley-Jory (Charcoal); This illustrates the benefits of taking a different perspective. Liz found this massive cedar and canopy in the Pacific Rim National Park.

Palm Trees in Ventura California by Katherine Tyrrell (Pen, ink and colored pencil); Drawn from my hotel bedroom on the last night of my road trip from San Francisco to San Diego.

Leave birdie holes

Every tree has gaps in its foliage through which you can see the sky. Thinking of them as holes for the birds to fly through will make sure you don't forget to include them in your drawings of trees (see opposite).

Drawing tree trunks

Tree trunks and branches are elongated cylinder shapes. The trick to making a trunk look cylindrical is to use lateral bracelet hatching, just as you would do when emphasizing the form of a leg. Palm trees make it easy for you.

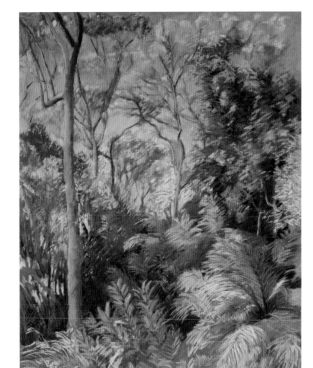

Sydney Back Garden by Katherine Tyrrell (Soft pastel); Eucalyptus trees and ferns in my sister's hillside garden in Australia.

Sheds and Fences by Lis Watkins (Pen, ink and watercolor); Drawn from a bedroom window.

227

Draw the garden from your window

If you have a garden, one excellent way to improve your technique is to draw your garden at least once a month.

228

Sit in your garden and draw

Your garden is a safe place to take on the challenges of sketching *en plein air*. The first thing you'll notice is that the light changes constantly and shadows move as time passes. Sit in one spot and draw how the light changes during the day. Also note how dark the shadows are on a sunny day.

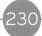

229

Draw gardens through the seasons

I visit some heritage gardens regularly and often sit in the same place and do the same sketch to record the changes. Flowerbeds seem like a challenge, until you start seeing flowers as shapes, masses and different types of marks.

230

Every green goes with every other green

It's a very interesting fact that greens never clash. Mixing your greens also makes them more interesting. That said, it takes practice to be able to mix and draw all the greens that you can see. Dark greens are a particular challenge (see also Tip 231).

Not a Lot of Room for Weeds by Katherine Tyrrell (Colored pencil); A sketch of the long border at Great Dixter in England.

Great Comp Garden by Katherine Tyrrell (Pen, ink and colored pencil); This drawing emphasizes extremes of light and shade in this garden in Kent, England.

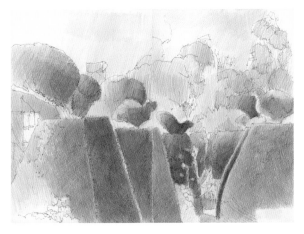

A Sketch of the Yew Bird Topiary at Great Dixter, England by Katherine Tyrrell (Colored pencil)

231

Generate intense and colorful darks

You often find very intense dark areas in gardens. Use complementary colors, such as crimson and green, to create deep colorful darks, and avoid black holes in your drawings.

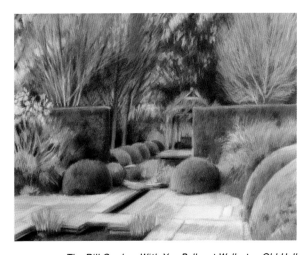

The Rill Garden, With Yew Balls, at Wollerton Old Hall Garden, England by Katherine Tyrrell (Colored pencil)

Sketch of Herb Garden, Sissinghurst Castle, England by Katherine Tyrrell (Pen, ink and colored pencil)

232

Draw yew sculptures

Sculptures in gardens can be man-made or natural, and yew can be both. Sculptures are excellent practice for drawing 3-D forms in landscapes.

WATER AND BOATS

Look at the differences in tone between a subject and its reflection in the water. Note how the darks are lighter and the lights are darker in a reflection. Waves also cast shadows onto the reflection.

Water does not lean

An obvious point, I know, but you'd be amazed at the number of drawings I see where the waterline is tilted—when it's nothing to do with perspective.

Waves and ripples: Focus on abstract shapes

Water's constant tendency to move can be confusing. Forget it's water and try drawing the abstract shapes you can see.

River Lea, Near Old Ford Lock in London, England by Liz Charsley-Jory (Charcoal); This drawing conveys movement and reflections in the water.

The relationship between water and sky

Water has no color. Its color comes from the sky and the atmosphere. Consider how the water in your drawing reflects its relationship with the sky and clouds.

Cast shadows and reflections on water

A cast shadow is the same sort of shadow that you would see if the surface it was cast on was land rather than water. Reflections always tend to be dominant (i.e., they ignore the cast shadow) except where the reflection is weak.

Mirror Plate Surface of the Water Garden at Giverny, France by Katherine Tyrrell (Colored pencil); Cast shadows on the left and reflections on the right. I've learned it's possible to keep making art out of water for a long time.

Tanah Lot, Bali, Indonesia by Katherine Tyrrell (Pastel);
*A lot of time was spent watching how the water and
surf pooled, flowed and changed in color.*

237

Boats

Squint when you look at boats and work out the
big shapes first. It's very easy to get befuddled
by an object you're not used to, and distracted
by all the detail. Plus, they will keep moving. So
squint and work out what the big shape is that
you need to get down first. If you get stuck, try
drawing very fast.

Nets at Cochin, India by Felicity House (Watercolor)

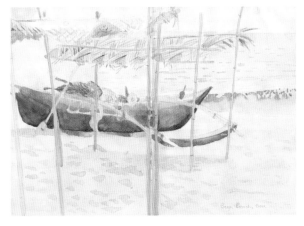

Baga Beach Boats by Katherine Tyrrell (Pencil and watercolor);
*My first ever sketch of a boat, with outriggers, in watercolor on a
beach in Goa, India (plus my first attempt at sketching a wave).*

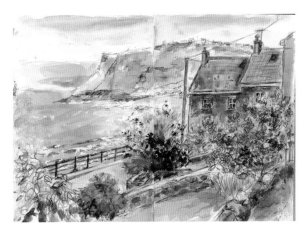

Sennen From Rose Cottage by Vivien Blackburn (Mixed media);
*My friend Vivien rents a cottage in Cornwall, England each year
with a wonderful view so she can draw and sketch the sea.*

SKIES AND CLOUDS

Skies and clouds are endlessly fascinating subjects. Plus, if you have a good view of the sky from your window, you can draw them from indoors as well as out.

Twenty Miles Outside Flagstaff, Arizona, USA by Katherine Tyrrell (Pencil and colored pencil); Long straight roads give you the opportunity to sketch skies and big cloud formations. Note the change in color of the sky from the horizon up (the temperature was 98°F/37°C).

238

Optical mixing

The subtle changes observed in the colors of the sky and clouds are particularly suited to optical mixing using techniques such as hatching and scumbling.

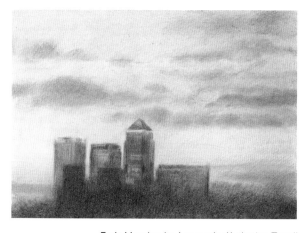

Early Morning in January by Katherine Tyrrell (Colored pencil); My "Canary Wharf Skies" series as seen from my kitchen window are all postcard size.

239

Draw the same sky all the time

Look at and draw the sky you see out of your window all the time—at different times of day, and in different seasons and weather. Observe how the clouds and the colors change, and how fast this happens.

240

Any old blue will not do

Blue skies are not easy. The blue hue varies depending on the season, weather conditions and time of day. Similarly, the tonal value of sky varies. Check tonal strength against your grayscale card, particularly around the horizon.

241

Draw light rather than hue

The sky is always lighter than the landscape. The dominant factor in how a sky reads is light rather than hue; test this by comparing the hue and tone of the sky near the sun to elsewhere within your view.

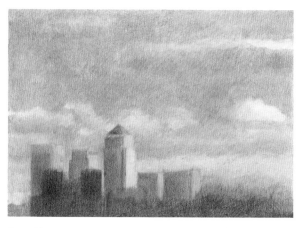

Late Afternoon in December by Katherine Tyrrell (Colored pencil)

Rolling In by Loriann Signori (Pastel)

Beltway Bliss by Loriann Signori (Pastel); Seen while sitting in traffic, and committed to paper two days later.

242

Do cloud studies

Use a tonal bar and a soft medium to shade and blend clouds of different types. Repeat this with different types of clouds.

Maritime Inversion, Big Sur, USA by Katherine Tyrrell (Colored pencil); Sometimes the clouds come down so low it's difficult to see the road, never mind the sky!

HOW TO IDENTIFY SKY COLORS

You can study skies any time you're out and about, and you don't need to be sketching.

- Assess tonal changes—it's easy to confuse tone when colors change.

- Create color swatches and a chart for sky colors according to the time of day, the season and the weather.

HOW TO OBSERVE CLOUDS

Observe what sorts of cloud go with what kinds of weather or times of the day.

- Develop sketch studies, as John Constable did, of how clouds change and develop.

- Create a color chart for different cloud colors.

- Observe and record how the types of clouds seen tend to change between seasons.

Vapor Trails by Katherine Tyrrell (Colored pencil); Early morning vapor trails near Mont Ventoux in Provence, France, sketched over breakfast.

TOPOGRAPHICAL DRAWING

The eighteenth and nineteenth centuries were the great age of topographical art. Many artists drew and sketched their way across Europe. The tradition has now revived, with an increase in interest in hand-drawn sketches on paper and using digital sketchbooks.

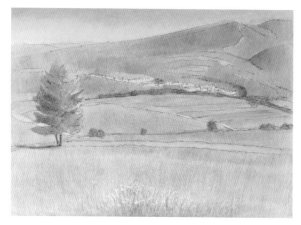

Sault and the Lavender Fields, Provence, France by Katherine Tyrrell (Colored pencil)

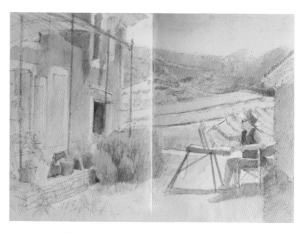

Sarah Painting the "Postcard From Provence" House by Katherine Tyrrell (Pen, ink and colored pencil)

Mont Ventoux and the Vines in Provence, France by Katherine Tyrrell (Colored pencil); The view from the house where we stayed.

243

Record what you see on your travels

Traveling to new places is a wonderful way to develop your sketching skills because it encourages you to draw the strange rather than the familiar. Draw whatever you see; it doesn't always have to be a nice landscape. Choose between lots of quickie sketches of different scenes or a smaller number of drawings that take more time. Focus on what you're most interested in, and limit your drawing to the key features you can see. Aim to finish your work within a predetermined time limit.

Give your drawing eyes a rest

Beware of the tiredness that comes with lots of new images; your brain gets tired of looking at lots and lots of brand new (to you) images every day. Remember to give your drawing eyes some time off too.

Bean Hollow Beach, Pescadoro, Northern California, USA by Katherine Tyrrell (Pen, ink and colored pencil); A quick sketch on a cold July day.

Swap notes with fellow artists

I enjoyed my trip driving from San Francisco to San Diego, California, USA because *plein air* painter and blogger Ed Terpening had given me excellent advice on good places to go to sketch. I now pass it on by giving tips to others about places I have visited. It's always good to share.

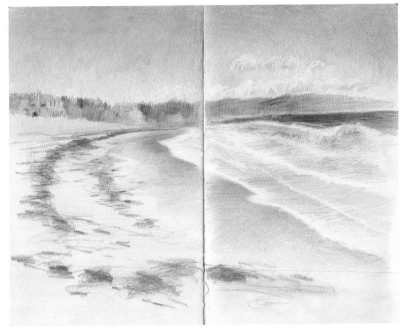

Scarborough Beach, Prout's Neck, Maine, USA by Katherine Tyrrell (Colored pencil); The home of Winslow Homer is in the trees—he used to paint the beach.

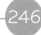

Draw a plan of locations

Your plan could be of locations you want to visit (I once had all the best spots to sketch in Venice all mapped out) or those you have visited and want to keep a record of. You could use the plan for a sketchcrawl, or give it to a drawing group visiting a place.

3. MIX UP YOUR MEDIA

If you'd like to become more confident using different art media and improve your drawing, why not have a go at experimenting with media or techniques you've not tried before. It's often one of the very best ways of making progress. This chapter covers a range of tips and techniques relating to:

- Different types of media used for drawing and sketching.

- More unusual media and supports.

You'll find that every sort of subject can be rendered in different art media—as you can see from the images in this book. The choices are limitless.

A selection of sketching tools and media.

DRY MEDIA

GRAPHITE PENCILS, STICKS AND POWDER

Graphite for art is available in pencils, as sticks and in a powder form. It's name comes from the Greek word *grapho*, meaning "draw" or "write." It is also known as black lead or plumbago.

247

High-quality pencils perform better

The most frequent tool used for drawing is a graphite pencil—a thin core of graphite powder mixed with clay and encased in wood. High-quality drawing pencils are both smoother and super-bonded to prevent them from breaking. They perform much better than ordinary pencils.

248

Investigate graphite brands and grades

Different grades of graphite make different marks and produce different tonal values.

Grades vary according to the amount of clay the graphite is mixed with. There is no standardized hardness attributed to the different grades. Grades of graphite pencils and sticks can range from 9B (the softest and blackest) to 9H (the hardest and lightest). It's worth trying different brands and investing in a tin of pencils of varying grades to discover which you like working with the best.

249

Achieving a quality finish

Avoid overworking graphite; it can become very shiny. Fixative must be applied when the drawing is finished to prevent smudging.

Graphite Realism, Study of Ciara by Alan Coulson (Graphite on paper); Alan exhibits regularly in the annual exhibitions of the Royal Society of Portrait Painters and the prestigious BP Portrait Award at The National Gallery in London, England.

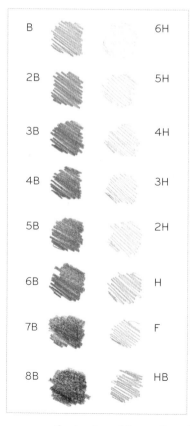

B			6H
2B			5H
3B			4H
4B			3H
5B			2H
6B			H
7B			F
8B			HB

Grades of graphite pencils and the marks they can make.

124

250

Try woodless graphite pencils

This pencil has a solid graphite core, leading to less waste and greater usability. If you want to cover large areas, graphite sticks are a much better option. Remove any protective coating and use them on their side like pastels.

251

Use a pencil holder to extend pencil use

Use of a pencil holder gives you a very easy way to extend the life of your pencil and save yourself money.

252

Check out sustainability

Some manufacturers are adopting a more sustainable approach to sourcing materials, manufacturing and waste management. Look for companies committed to renewable resources and solvent-free production.

253

Graphite powder

Graphite powder is best used on a surface with tooth. It works like powdered charcoal and soft pastels. Applicators include fingers, brushes and soft shapers. A putty rubber is effective at erasing marks. Use with care as inhalation of dust in the short term may irritate your lungs.

A pencil holder is useful for drawing with short pencils.

Graphite stick and artists' pencils.

Cosmo by Katherine Tyrrell *(Pencil); A quick pencil sketch of my cat Cosmo.*

OTHER TYPES OF PENCILS

254

Try a mechanical pencil

Also known as a propelling pencil, this type of pencil is extremely useful for drawing lines of a consistent thickness. It has four unique features:

- **Good balance**: It doesn't wear down and thus is better balanced.

- **Constant core**: The case contains a storage area for extra pieces of graphite, which are automatically propelled out the end of the holder.

- **No need to sharpen**: The fine graphite core never needs sharpening.

- **Break resistant**: Modern cores are very strong, often coated in polymer to resist breakage.

Cores are available in different thicknesses—usually defined in millimeters—and different degrees of hardness.

The difference in marks between graphite (left) and carbon sticks (right). Carbon produces a denser black.

255

Carbon pencils

This pencil produces very dark tones like charcoal but is much smoother and much nicer to draw with as it is less messy.

Mechanical pencils

256

Clutch pencils

A variation on the mechanical pencil, the core is gripped and held in place by a claw. Thicker cores are inserted one at a time and require sharpening.

Cynara Cardunculus (section) by Coral Guest
(Carbon and graphite on paper); Use of carbon enables a much better range of values than can be achieved using graphite alone.

257

Holding a pencil correctly

Drawing is very different to writing. People who have not been taught to draw often draw by holding a pencil as they do for writing, with their fingers very close to the writing end. However, the way you hold your pencil to draw can radically improve the range and quality of the marks you make.

- Use your whole arm to draw as it increases the size and flow of possible marks, and allows you to work more easily on larger paper.

- Change your grip so as to avoid your drawing being too "tight." This also makes it easier to make a range of different marks.

258

Charcoal pencils

These have a charcoal core encased in wood, and vary a lot in quality. This is one item that is definitely worth testing in an art supplies store because some are scratchy. Use a charcoal pencil to restate and emphasize line in charcoal or pastel drawings.

259

Lithograph pencils

Lithograph pencils are used for creating lines on media used to produce lithographs. They typically vary in softness from #00 (very soft) to #5 (hard).

CONTROL OVER MARK-MAKING

These suggestions will help you achieve better control of your pencil and therefore more consistent mark-making. They apply to most dry media.

Drawing: Basic tripod/pen grip
Grip near the point to limit the stroke length and achieve good control for fine detailing using only the tip. This grip limits the scope of how the pencil can be used.

Drawing: Basic grip
Drawing can become looser when the pencil is gripped farther away from the tip. It creates more scope to use a wider range of marks, including hatching.

Drawing: Overhand/gesture grip
This grip enables drawing from the shoulder, more free-flowing lines, a range of mark-making techniques, and wider sweeps on large paper. It works well for drawing on a vertical plane or when using the side of the core or stick to shade.

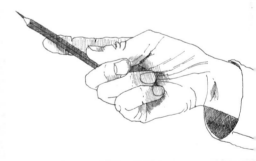

Drawing: (Extended) underhand grip
This is a very loose method of holding a pencil and is good for people who have problems with grip. I use the extended version (hold near the top of the pencil) and it is very effective for fast, controlled and measured hatching.

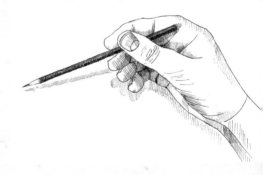

COLORED PENCILS

Use artists' brands

Artists' colored pencils are much better quality than those made for and used by children. They are pigment-rich, and very smooth in their application. A full set of artists-grade pencils is not cheap. Try different brands by buying from open stock and build up your collection slowly.

Choose between wax- and oil-based pencils

Artists' colored pencils are either oil- or wax-based and both work well. Wax-based pencils tend to feel creamier than oil-based pencils. They also work better with heat (see Tip 266). "Wax bloom," which looks like a milky film, can appear if wax pencils are overworked or heavy pressure is used.

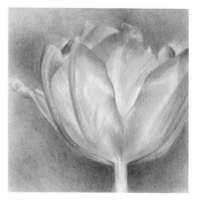

Tulip by Katherine Tyrrell (Colored pencil); This demonstrates how optical hatching in the background prevents a drawing from looking flat.

Use very sharp pencils and a light touch

Very sharp pencils are the most effective. Layer different hues using a light touch. Avoid pressing down as this flattens the paper.

Use lightfast pencils

Lightfastness matters when selling drawings. Always check the lightfastness of different brands and hues. ASTM International has set a standard for the lightfastness of colored pencils, but only one brand is fully compliant (see bibliography on page 168: *CPSA Lightfastness* book).

Sample different supports

Colored pencils can be applied to a tremendous range of surfaces. Share paper with friends to sample as many different surfaces as you can.

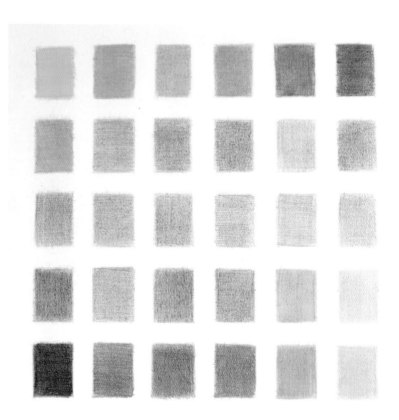

With colored pencils, all the color mixing takes place on the paper. Complementary colored pencils (top and bottom) layered in different proportions to create tertiary colors in an optical mix.

265

How to make a mark with colored pencils

There is no "right way" to use colored pencil. Below is an introduction to different ways of building color. The image on the left illustrates the basic application while repeated application is on the right. Some techniques are much slower than others. Read page 130 for techniques that help speed up the drawing process

Circulism: This technique is similar to polishing and involves drawing tiny circles that overlap, interlink and change in size as you continue to work. Some artists like their circles to show, while others use them very lightly as a method for laying down colored pencil.

Hatching: This works in exactly the same way as any other method of hatching. You can choose the direction of the hatching and whether it has any shape, such as bracelet hatching. You can also choose whether you overlay with crosshatching from a different direction.

Optical hatching: Create optical mixes of different colors by layering one color over another using open hatching. This allows the color underneath to show through. Repeated layers of the same colors allow adjustments for saturation and tone.

This method is particularly effective if you are using a very controlled color palette of complementary or analogous colors.

Scribbling: A scribble involves a line moving in a random direction without lifting off the paper. Anybody can do this and children frequently do. Scribbling in an artistic way is more difficult than it looks. The artist John Smolko has created a signature style that involves scribbling. It's a technique to try if you don't want your drawings to resemble photographs.

Scumbling: This technique works best on an abrasive support with tooth. The core does not require a point but does need to be exposed. Drag the core sideways over the support so that it catches the tops of the surface.

Vertical lines: This technique involves very small vertical strokes and lifts off with every stroke. It is very slow, and drawings take many hours.

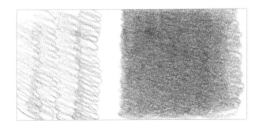

Circulism

Scribbling

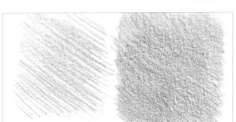

Hatching

Scumbling

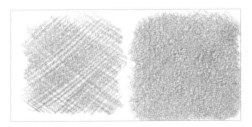

Optical hatching

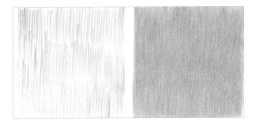

Vertical lines

266

Melt pencils to speed up drawings

There is no great virtue in taking a long time to complete drawings. What's important about a drawing is the end result, not how you reached it. There are various ways to speed up drawings that involve melting pencils so they can be spread around more easily. This also helps with the development of saturated colors.

267

How to disperse pigments quickly

Eco solvents
Eco-friendly solvents are an efficient way of creating an underpainting or developing saturated color quickly using wax- or oil-based media. The solvent can help melt, dilute and blend. Media can be brushed across a support, and tint strength can be varied in much the same way as you can with paint.

Heated wax-based media
Wax pencils soften when exposed to heat and solidify again when cooled down. When warm, it's much easier to spread wax-based colored pencils using silicon shapers. Wax can rise to the surface and create a white haze known as bloom. Wipe this away with a cloth.

Watercolor pencils
Artist-grade watercolor pencils dissolve using water. The quality of the brand and the amount of water used determine whether pencil marks remain detectable.

Baby oil for oil-based pencils
Use a blending stump, tortillon (page 160) or empty colorless marker pen to apply tiny amounts of baby oil or mineral oil to spread and blend oil-based pencils.

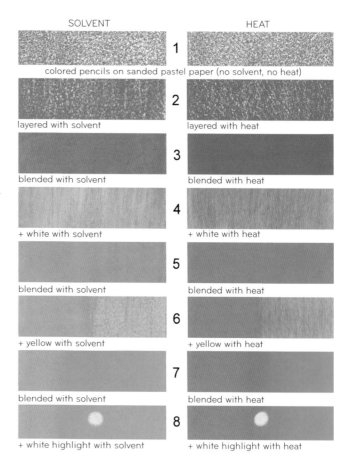

SOLVENT HEAT

1 colored pencils on sanded pastel paper (no solvent, no heat)

2 layered with solvent / layered with heat

3 blended with solvent / blended with heat

4 + white with solvent / + white with heat

5 blended with solvent / blended with heat

6 + yellow with solvent / + yellow with heat

7 blended with solvent / blended with heat

8 + white highlight with solvent / + white highlight with heat

Comparison of the effects of solvents and heat on the blending of wax-based colored pencils by Ester Roi.

Symbiosis by Ester Roi *(Colored pencil); This drawing was produced using heat to melt Ester's wax-based pencils.*

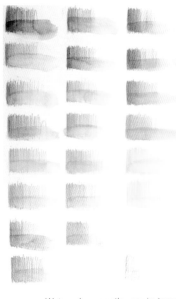

Watercolor pencils vary in terms of how easily the marks made by the pencils are lost when wetted.

Ashness Bridge, Derwent, Cumbria, England by Malcolm Cudmore (Colored pencil)

I prefer different brands of lightfast color pencils for fine art, and use lots of different brands for sketching.

Zen by Nicole Caulfield (Colored pencil); Muted colors and colored grays are as important as bright colors.

PASTELS

A pastel is created from a paste of finely powdered pigment and a binder of gum or resin water. Powdered kaolin or chalk is sometimes added if the pigment source is very hard. Pastels used to be called chalks in the past.

DIFFERENT TYPES OF PASTEL

Pastels are typically made in a stick form but also come in other shapes and sizes. A soft pastel is rated by how easily it releases its pigment load. You can obtain a useful chart that ranks different pastels by softness from Dakota Pastels (www.dakotapastels.com/docs/Pastel-Lineup.pdf). The general principle is "soft" over "hard."

- **Soft pastels** typically have a wrapper due to their softness and their ability to transfer color to anything they touch. The degree of pigment load and softness varies from brand to brand. Very soft pastels can fill the tooth of a paper very quickly.

- **Hand-rolled high-quality pastels** typically include much more pigment and less binder, resulting in softer pastels that create saturated colors easily.

- **Machine-made pastels** tend to include more binder to cope with the extrusion process.

- **Hard pastels** typically do not have a wrapper and are not soft. Hard pastels are also usually machine made.

- **Pastel pencils** are simply a hard core of pastel encased in wood. They produce the same type of effect as hard pastels but with less coverage.

- **Oil pastels** are a completely different product that also happen to adopt a stick format and the pastel name.

268
Try a variety of pastels

Different brands of pastels vary a lot in terms of the marks they make. You haven't really tried pastels as a medium until you've tried a range of different brands and degrees of softness.

270
You don't have to fill all the paper

You can always leave the background showing. Try different-colored supports to see what impact this has on your finished drawing.

271
Take the wrapper off and break the stick

All parts of the stick, sides and edges, can be used to make marks on paper or other supports. Smaller pieces are easier to use when scumbling across the support.

269
Use pastels so they look like pastels

Make the most of the distinctive nature of the medium you are using. Trying to make it look like another medium will always produce a less than best result.

Hard pastels in contemporary colors.

272
Traditional uses of hard pastels

Hard pastels are excellent for creating a clear and sharp outline. Use hard pastels for sketching. Try creating an underdrawing, roughing in large, flat areas of color as a guide to developing a drawing. Hard pastels are also good for defining detail and restating lost edges and definition. Use the edge of the square stick to create a crisp, sharp line. Hard pastels can also be used for very detailed rendering of intricate details.

273

Good uses of soft pastels

Use the side of soft pastels to cover large areas quickly. Mix colors optically using the tip or edge. Create more vibrant color using the techniques covered in this book. For example, scumble lightly on an abrasive colored ground so that the color shows through, or use the tip of the pastel for hatching and feathering. Try blending and smudging colors, and add accent colors at the end.

Stir Fry Pastel by Felicity House (Pastel over tonal watercolor washes on Colourfix card); This piece exhibits careful draftsmanship, and looser strokes in the background and shadows.

274

Use pastel pencils for edges and details

Pastel pencils are best used for details and edges and restating parts of a drawing that need definition. They don't cover large areas either quickly or easily, but do keep your hands cleaner.

275

Use optical hatching

Pastels lend themselves to blending colors through optical hatching. Practice creating color swatches and vary the color mixes and the spacing between strokes to create a range of different colors.

Poolside White Hat by Sally Strand (Pastel and watercolor); Optical hatching of soft pastels on top of a broad-brush, big-shapes underpainting in watercolor.

276

Organize pastels by hue and tone

When arranging pastels, sort them by hue and tone. It's then much easier to see how you can use other colors of the same tone to add interest and variety to a drawing.

277

Use a brush and water to create a wash

As with charcoal, it is possible to create a wash and an underpainting by mixing pastels with water and using a sponge or brush to spread the color. Pastel strokes on top of a hand-painted colored ground have impact and are very effective.

Hot Mamas by Loriann Signori (Pastel); Loriann has a talent for keeping her pastels looking very fresh and vibrant despite blending colors.

278

Work from dark to light

Work on a toned ground in a neutral or complementary color. Start with darks and more subdued colors and bring the piece up to the more vibrant and lighter colors.

279

Don't overdo blending

Overuse of fingers or paper stumps for blending can leave a pastel drawing looking very flat, with faded or muddy colors. Maintain clarity in your mark-making and keep colors vibrant by blending only small areas such as soft edges.

The working plein air palette of Kathy Falla Howard.

280

Be careful about health and safety

Pastels are dry and create dust. Periodically you must remove the dust from your work and be very careful not to inhale any of it before you apply a fixative. To minimize the amount of dust you're exposed to, work vertically at an easel so as to allow dust to drop into a dust trap, and vacuum dust up as you go. Take the support outside, stand upwind and bang it firmly on the back and shake to get the loose dust to drop off. Fix periodically after you have removed very loose pastel dust. It is much better to spray several light coats than a heavy burst, which can ruin all your hard work.

281

Protect pastel drawings

Use a light spray of fixative to bind the pastel marks to the support. Note, however, that this can darken and/or deaden colors. Use glassine paper to wrap pastel drawings and prevent damage when stored or being transported. Make a foam core sandwich to keep glassine-covered pastel work safe and secure from damage during transportation.

282

Protect your hands

Pastels are very dry and absorb the natural oils and water in skin, leaving you with extremely dry hands. Barrier cream will prevent this. (For additional options, see page 137.)

283

Create traditional portrait drawings

Black, white, sanguine and sepia work very well on neutral-colored paper.

Study the drawings of the classical masters of drawing, such as Michelangelo, to see how they used their chalks to create very expressive drawings.

Also study the portrait drawings of Hans Holbein. Use red chalk and/or pen and ink for the contours and then apply traditional colors of pastel very lightly to indicate form.

FIGURE DRAWING AND *LES TROIS COULEURS*

Traditional Conté crayons comprise the same colors and were used by past masters of classical drawing. They are made from natural pigments, clay (kaolin) and a binder. Colors include black, gray, white, sanguine or blood red and sepia or brown.

Traditional pastels in a tin.

Pastel pencils require a scalpel to sharpen them.

CHARCOAL

Charcoal is a widely used dry art medium. Nothing achieves black like charcoal.
Black carbonized sticks are produced when wood is burned and all water is removed.
The quality and color of a charcoal line depends on the type of wood and how
it was produced.

LEARN ABOUT ART CHARCOAL

Various types of charcoal are available, including:

- **Vine charcoal**: Typically created from willow or vine.

- **Compressed charcoal**: The charcoal is mixed with gum and compressed to create sticks of a uniform size and shape.

- **Charcoal pencils**: Compressed charcoal in an extruded stick form, plus a protective cover that eliminates dirty hands. It is difficult to sharpen and difficult to erase.

- **Powdered charcoal**: Carbonized wood ground down to a very fine powder. It is used to create tone and cover large areas quickly and easily. It is also traditionally used in a bag for pouncing—the transfer of an outline drawing to a canvas support. Always use it with care.

284

Compressed charcoal produces intense darks

Compressed charcoal has a lot of impact and easily covers large areas. The black is very dense and is not easily removed. Apply the charcoal on its side and drag it across the support to produce bold strokes.

285

Use vine charcoal for sensitive lines

You can create an edge in vine charcoal so that it produces a thin, precise line drawn with sensitivity. It is much softer than compressed charcoal and can be wiped off easily. It is possible to produce very fine and subtle gradations in tone.

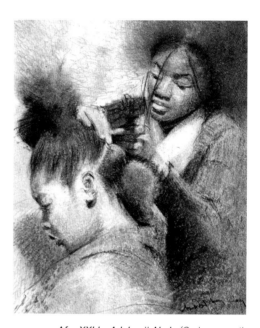

Afro XXI by Adebanji Alade (Carbon pencil, charcoal dust and graphite)

Vine charcoal is rarely straight. Compressed charcoal is usually a uniform stick.

286

Use vine charcoal for underdrawings

The major advantage of vine charcoal is that it can be wiped off and redrawn with ease using a cloth. It is often used to work out the main shapes and lines of a painting. Vine charcoal makes an excellent medium for creating an underdrawing as it can be reduced to just a whisper of the original drawing very easily.

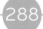

Mix charcoal with water to create a monochrome drawing

Charcoal mixes with water easily and the resulting wash can be used in a life class to great effect. Use a brush to apply the wash around the paper.

288

Use good-quality papers for fine-art drawings

Cheaper low-grade paper is fine for quickies and life drawing. However, you should upgrade your paper if intending to sell any fine-art drawing using charcoal.

Grand Central Station, New York, USA by Jeanette Barnes (Charcoal); Jeanette creates her extremely large drawings in charcoal in her studio using lots of smaller studies drawn on location.

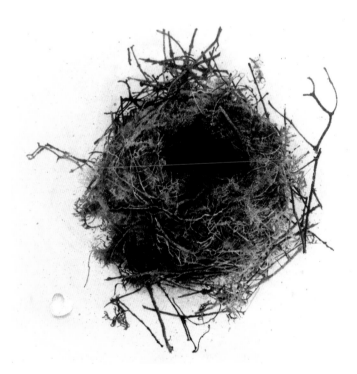

Gone by Sarah Gillespie (Charcoal and watercolor on paper)

289

How to keep your hands clean

It's fine to use your hands to blend charcoal on the paper. However, dirty hands transfer charcoal to everything you touch. Stay cleaner by using:

- A barrier cream or gloves.

- A tool to hold the charcoal.

- A brush, rag or tissue to blend charcoal.

- Wet wipes to clean your hands quickly and easily.

- Charcoal pencils (although this is less advisable if you are wanting to cover a large surface).

WET MEDIA

PEN AND INK

Pen and ink has been used for drawing for thousands of years and continues to be one of the most popular media among artists.

TYPES OF INK

Types of traditional ink:

- **Indian (dip only)**: Permanent and water-resistant.
- **Sumi**: A very dense black ink.
- **Chinese**: Usually in stick or stone format.
- **Iron-gall (dip only)**: Made from oak-galls. It is waterproof when dry and darkens with age. It was used for drawing in Europe until the nineteenth century.
- **Bistre**: A very dark shade of grayish black. It was traditionally made by boiling soot.
- **Traditional drawing inks (dip only)**: Includes shellac, such as sepia.

Types of contemporary ink typically based on dyes:

- **Colored acrylic drawing ink**: These are typically non-permanent.
- **Calligraphy ink**: These are available in various colors.

Use the following terms when talking about ink:

- **Shellac**: A natural form of plastic that resists UV light.
- **Waterproof/resistant ink**: A pigment-based ink that binds to the paper and is impervious to water and solvent.

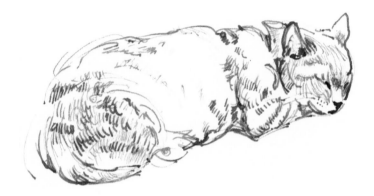

Pearl Sleeping by Laura Frankstone (Sepia ink); Drawn using a reed pen.

290
Use ink to draw without erasing

I learned more about drawing when I made myself draw in ink than I ever did when I used an erasable medium. Drawing in ink makes you look so much more carefully, and your drawing benefits as a result.

291
Experiment with different types of ink

Explore the amazing range of drawing inks available, paying attention to the colors, constituents and whether they are lightfast. Note also the nature of the washes that each ink makes—some are more interesting than others.

292
Use water-resistant ink with a watercolor wash

The mistake of putting a watercolor wash on top of non-waterproof ink is not forgotten quickly. Use watercolor on top of permanent and waterproof ink, or alternatively over a pen that can handle waterproof ink. Do not use good-quality brushes with waterproof ink.

293
Use water-resistant inks in dip-type pens

Do not use waterproof/water-resistant ink in any pens that will be ruined if the ink dries. If used in a technical or fountain pen the ink needs to be flushed through as soon as the pen is laid down, otherwise it will dry inside the pen and render it useless.

294

Try traditional pens and nibs

Use fountain pens if you want a line with variation. The degree of bend in a nib varies depending on what it is made of and who manufactured it.

- Use a reed pen if you want to try drawing like Vincent van Gogh.

- A quill pen is made from the flight feathers of a large bird, usually a goose. Tips are usually square cut then cured in hot sand. They're no more expensive to buy than a contemporary pen.

- Try a dip pen if you want to use permanent water-resistant ink. There are various options in terms of nibs and penholders.

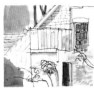
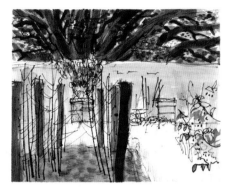

Indian ink sketches by Felicity House
(Pen and Indian ink)

295

Try unconventional implements for drawing

Twigs and the wooden stirrers for tea and coffee also make suitable implements for drawing with ink.

Shadow Palms by Melissa B. Tubbs (Pen and ink); Melissa uses very controlled hatching to produce her drawings.

Experiment with contemporary pens

There is a vast range of pens on the market. Test pens by creating a set of swatches of the marks they can make. Technical pens produce a consistent line of a specific thickness and are often used to produce precise drawings using hatching and crosshatching. Pigment liners are available that are lightfast, waterproof and indelible. They're also great for doing illustrations for publications. Marker pens produce a line with more impact and are typically used for drawing contours (see James Hobbs' *Clissold Park* image on the right).

Clissold Park, England by James Hobbs (Marker pens); *Two panoramas stacked one on top of the other.*

Teasels by Katherine Tyrrell (Ultrafine rollerball); *I'm very fond of drawing with a 0.4mm rollerball, which produces a fine line of just 0.2mm.*

Ballpoint pens

In the hands of an expert such as Andrea Joseph, stroking smooth paper softly with a ballpoint pen can produce very soft textures and stunning drawings. Use stippling and hatching to create halftones. Keep your pen point free of blobs by wiping it on a regular basis.

Use grayscale marker pens

Using these is a good way to train your eye to see gradations between black and white, and to develop tonal-based thumbnail sketches. They also allow you to cover paper with tonal values quickly.

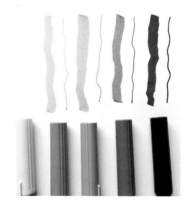

Grayscale marker pens; used for drawings that focus on simplifying tones.

BRUSHES

Brushes can be used for any wet media—such as drawing inks or watercolor.

Choose a suitable brush for sketching

When sketching you want to try and execute most of the sketch using one brush. Brushes with a small body that don't hold much water or media are both frustrating and produce scrappy sketches. Opt for a brush with a good body that can hold a reasonable amount of media/water and also produces a fine point.

Use a retractable brush for travel sketching

To avoid damage to a brush when traveling try using a small retractable brush. The brush comprises two parts:

- A short barrel with a brush attached.

- For travel, a hollow cap covers the brush. This then becomes a barrel extension for use when sketching.

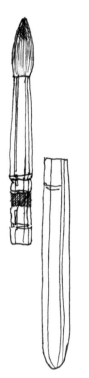

A retractable brush

Draw with your brush

You can use a brush to draw as well as paint. It works the same way as pen and ink—you will find you focus much more on what you are doing and consequently develop your skills in using a brush.

Use a waterbrush

Waterbrushes are the brush of choice for many sketchers because they eliminate the need for a water pot.

You can also generate a consistent pale ink wash using a waterbrush. Fill a waterbrush with a mix of ink and water to produce a wash mixture with a consistent color.

Use more than one waterbrush for washes with different tonal values.

The wristband wiper

Liz Steel showed me how a dark tennis wristband is invaluable for wiping your brush on before changing colors when out sketching. See a sketch of her own sketching tools on page 143.

Waterbrushes by Shirley Levine
(Pen, ink and watercolor); This is Shirley's favorite art tool.

WATERCOLOR

Watercolor is a very traditional sketching medium. It has been favored by many famous artists in the past, including J.M.W. Turner and John Singer Sargent. For sketching, it is most often used as a wash in conjunction with drawings in pencil or pen and ink.

Full pans, half pans and tubes of watercolor paint.

304
Lightfastness

If you intend to sell your work, or to frame and hang it, you need to think about lightfastness. Ensure you use paints that achieve a Class I or II lightfastness rating.

305
Develop a color palette for sketching

Choosing the right colors for your sketching palette is a subject of much discussion in social media. Make friends by sharing your palette and asking for recommendations regarding colors in turn.

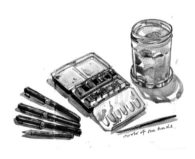

Tools of the Trade by Lis Watkins
(Watercolor)

306
Choose between artist- and student-grade paint

Student-grade paints are cheaper but often use cheaper pigments that are not always lightfast. Artist-grade paints are much more pigment rich, produce saturated color faster and maintain strength of color when used as a tint.

307
Choose between pans and tubes

The choice of pans or tubes is a matter of personal preference. However, your sketching kit is typically more compact and easier to carry if you use pans.

308
Choose between a large and a limited palette

The choice of using a full-size or a limited palette is essentially a personal one. It's how you use it while sketching that matters. Get an extra row of half pans in a pocket watercolor box by taking out the metal section, then inserting pans of watercolor paint secured by putty or tack.

309
Choose between a waterbrush and a traditional brush

Waterbrushes mean you don't need to access water to sketch in watercolor. Having several waterbrushes available will enable you to use different ones for different colors.

A good-quality traditional brush gives you much better control but does require a pot of water.

310
Reserve the lights

Sketches are less dense and more filled with light if you reserve the highlights and areas of lighter tone and leave them completely untouched by paint.

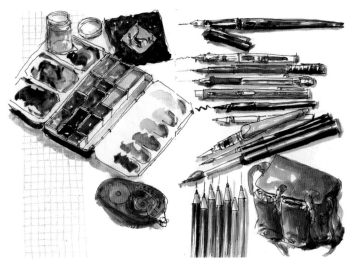

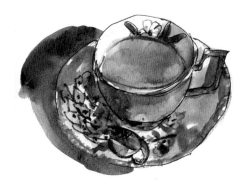

New Blue Cup by Liz Steel (Watercolor and ink)

Current Sketching Tools by Liz Steel (Watercolor);
Note the black toweling wristband used for wiping brushes.

Lippiano, Umbria, Italy by Mat Barber Kennedy (Watercolor);
Developed from a sketch, this piece combines realism and creativity.

After the Party by Lis Watkins (Pen, ink
and watercolor); *Reserving white space
helps to define both shape and form.*

DIGITAL MEDIA

People now use smartphones and tablets for drawing. A variety of apps offer an amazing range of options for digital drawing and sketching. Here are some tips for those new to drawing using digital media.

311

Use the Internet to keep abreast of developments

Technology changes so fast that there's no point writing about what's available at present as it could be out of date before this book is published. Instead, here are a few questions to consider:

- Which operating software is required to run an app?

- How much space will the app need to install?

- What size of file does it create?

- How can you transfer files between your device and your image archive?

My iPad mini and stylus; my second sketchbook. The cover enables the screen to be angled.

312

Try out different hardware options

Pioneers of digital drawing on mobile devices (e.g., David Hockney) and hobby artists now use pretty much the same hardware. Devices suitable for digital drawing on the move include an Android tablet, iPad or a smartphone. Professional artists are more likely to use a larger graphics tablet attached to a computer.

313

Test out different drawing apps

Software options for drawing using pressure-sensitive graphics tablets are packed full of features, challenging to learn and not cheap. They are used by professionals and generate the best-quality results. In contrast, apps for mobile devices are very inexpensive yet still provide sufficient features for the more casual user. Try a few to find the one you like the best.

314

Start simply, one step at a time

Learning how to use a new medium takes time. Digital media is no different from any other. Learn one app and one function at a time. Trying to learn lots of different apps at the same time can be really confusing.

315

Try a stylus

A stylus looks like a pen or pencil but has a tip with the capacity to draw on the surface of a touchscreen device. It can offer more control than a finger. Go for one that has good reviews and has a tip that will not wear out too quickly or get lost.

316

Sample and experiment

The big advantage of digital media is you waste nothing—except a bit of battery life. Try out ideas and work through thumbnail options for different crops and treatments, and experiment with color.

American Art in NYC, USA by Walt Taylor (Digital drawing)

DIGITAL MEDIA APPLICATIONS

Digital media suitable for drawing and sketching include tools such as:

- Blenders
- Charcoal
- Colored pencil
- Eraser
- Graphite pencil
- Mechanical pencil
- Marker pens

- Oil pastels
- Soft pastels
- Traditional nib pen
- Watercolor
- Wax crayon

The size and width of a line can be varied, as can its opacity. In addition, the software can create a variety of surfaces for use with the drawing media.

TYPICAL FEATURES OF A DRAWING APP

Most apps will allow you to choose and/or customize:

- The type of support to use (it emulates different surfaces).

- What sort of media you use.

- The color palette and how many colors to use. This means you can have a much bigger range of colors than those you might normally carry if working outside the studio or home.

- The mode and size of the drawing tool.

- How many layers to use.

- The zoom function, which is particularly helpful to those who have problems with their eyesight. You can zoom in to draw detail or see more clearly.

Tree by Katherine Tyrrell (Digital drawing); *Adjust the width of the mark and the transparency control to create digital scumbling with digital pastels. This allows you to see layers underneath.*

MIXED MEDIA

You'll learn more about mark-making and drawing the
more media you try and the more media you mix.

Tuckenhay Creek, England by Sarah Gillespie
(Charcoal and sepia ink on Arches paper)

Ringles Tangles by Tim Wootton (Marker pen and watercolor wash)

Embankment, London, England by James Hobbs
(Digital color and marker pens)

317

One new drawing medium every month

Repeat exercises in this book with a new
medium. Observe the differences between your
usual medium and this new one.

318

See if you prefer dry or wet media

There's something about the feel of the
drawing implement upon the support that
means you are likely to end up favouring
wet or dry media.

MIXED MEDIA OPTIONS

Examples included in this book:

- Pen, ink and watercolor
- Pen, ink and colored pencils
- Graphite and colored pencils
- Graphite and watercolor
- Graphite and digital color
- Carbon pencil and charcoal
- Ink and charcoal
- Charcoal and pastels
- Permanent marker pens and watercolor wash
- Marker pens and digital color

Plus you can also vary the supports
you work on...

UNUSUAL SUPPORTS FOR DRAWING

Some examples of some of the more unusual contemporary
media that people have chosen to draw on and with.

319

Tell a story on a scroll

Chrys Allen, winner of the inaugural
Derwent Art Prize for pencil art, draws
on scrolls. This method of recording
visual images transforms drawing into
storytelling and has a long history
across many countries and cultures.
The scroll is typically wound up at both
ends with only the portion being used
for drawing exposed. It's then unfurled
for display.

Walk in Progress: Towpath by Chrys Allen
(Mixed media); The meandering of the "towpath" scroll
enhances the sense of movement and rhythm.

320

Decorate a guitar

Maggie Stiefvater is a best-selling
author, artist and musician. She draws
freehand on guitars with a marker pen.
Like the artists who decorated early
manuscripts, she is fascinated with
making everyday, useful objects
into art.

Guitar by Maggie Stiefvater (Marker
pen); Maggie's designs are based on
the early Celtic and Scandinavian art
associated with the Lindisfarne Gospels
and the Book of Kells.

321

Try line drawing in metal

The convention with drawing is that you
reduce a subject with three dimensions
to a picture format in two dimensions.
However, you can also draw in 3-D, and
fine artists frequently do. The welded
sculpture by Harriet Mead pictured
here was made from found objects.

Pick Axe Hare by Harriet Mead
(Welded found object)

322

Try "drawing as walking"

Richard Long's "A Line Made by
Walking" was a landmark event in the
development of contemporary drawing.
As a student, he walked up and down
on grass until it was flattened and
appeared as a line, and then
photographed it. You can see the
photo online.

ART PAPER AND SKETCHBOOKS

Your decision about which paper to use for drawing will be a major influence on what the end result looks like.

323

Learn about fine-art paper

Understand how paper is made to help you choose the right sort of support for your work. Learn about the different characteristics of art paper and the differences between hard-sized and soft-sized paper.

325

Understand different types of paper

Fine-art paper
This is used for drawing, watercolor and printmaking. Different brands have different characteristics, although they are usually archival and acid-free. They are made of 100 percent cotton, and additives may include sizing and optical brighteners.

Drawing/cartridge paper
Suitable for quick studies and drawings with a temporary life. It is made partly or totally from wood cellulose and is sometimes acid-free.

Cheap newsprint
Thin, low-cost, non-archival paper often used in life classes. It deteriorates and becomes brittle over time.

Pastel support
Paper and boards have a texture called "tooth." Some heavier supports have an abrasive texture.

324

Understand different surfaces

Fine-art paper can have different surfaces. These vary according to how they were made.

Rough/torchon
A rough surface with hills and dimples. Wet media settles in the dimples; dragging dry media lengthwise across the surface tends to catch the hills and miss the dimples.

Cold press/NOT/grain fin/vellum
A slightly bumpy texture often used by watercolor painters and pastel artists who use their medium as a wash. Vellum is smoother but also has a slight tooth.

Hot press/grain satiné/plate
A paper with a fine, smooth texture, enabling great control of detail. It is used for drawings in pen and ink and by botanical artists.

Laid paper/Ingres paper
This has a ribbed texture and is available in neutral or vivid tones. It is often used as pastel paper.

Woven/vélin paper
Made using a woven wire base, this has a uniform surface on the right side. It is typically not watermarked.

A fine-art paper store.

326

Understand paper weights

The thicker the paper, the heavier it is and the more robust it is. Standard weights of fine-art watercolor paper are:

- 90lb./180gsm
- 140lb./300gsm
- 300lb./640gsm

Papers sized according to the A system by Bromskloss (CC BY SA 3.0).

327

Understand imperial and metric sizing

Paper comes in sizes that vary according to the country in which it is made. Imperial sizing (given in inches) is used in the US, and metric sizing (given in centimeters) is used in the UK and Europe. The metric system corresponds to the International Standard for Measuring Paper ISO 216, which is used in most parts of the world. In this system, the height-to-width ratio of all pages is the square root of two (1.4142:1).

Colored pencil on black paper.

328

Try different colors of paper

Artwork can look wonderful on paper that is not white. However, not all media work well on colored paper, so you need to do a bit of experimentation first. Black can be very difficult to work on as the colors tend to sink.

329

Learn about sizing

Fine-art paper is sized. A substance is added that affects how permeable the paper is. This affects both wet and dry media. Size can be applied both internally and on the surface. Color sits on the top of paper that is hard-sized (e.g., Arches) whereas it sinks into paper that has a soft size (e.g., Saunders Waterford).

330

Learn which side is the right side

Paper has two different sides. The right side of a good-quality paper is the side where the watermark reads correctly. Paper is designed so that you work on the right side, although you can, if you prefer, work on the other side.

(Left to right) Vellum paper, drawing paper, hot pressed, cold pressed and rough surfaced.

Experiment to find the type of surface you like best

Try the same drawing on different surfaces to test out what happens. On this page you can see examples that include both wet and dry media marks on rough paper, cold-pressed paper, hot-pressed paper and Ingres or laid paper.

Archival paper is a must if you plan to sell your drawings

Drawings intended for sale should be made on archive-quality fine-art paper that will not deteriorate. Archival paper is robust and will be accredited to a paper conservation standard. It will also always be acid-free.

Try different formats

Trying a different format (e.g., landscape, portrait, concertina, scroll or panoramic) has a positive effect on creativity and drawing.

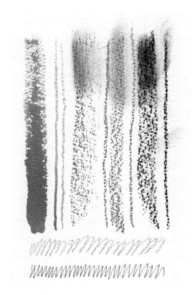

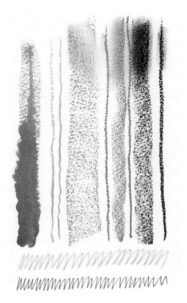

Rough paper *Cold-pressed/NOT paper*

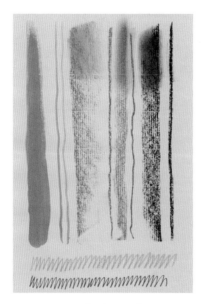

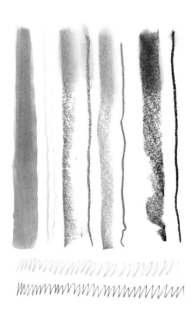

Laid paper/Ingres paper *Hot-pressed paper*

On each surface above, the marks are made using (clockwise from left): Watercolor, Conté crayon, graphite stick, carbon stick, graphite pencil and blue colored pencil.

Santiago de Compostele by Jennifer Lawson (Pen and ink); Sketch in an accordion sketchbook, sometimes called a Japanese accordion sketchbook. The paper is continuous and folds flat. Consequently, these are suitable for extended panoramas. The number of pages varies according to the brand.

Walk in Progress: Koli by Chrys Allen (Graphite); Winner of the inaugural Derwent Art Prize for pencil art. Scrolls are an ancient way of recording drawings of events, routes through a landscape and pictorial stories recording the history of the world.

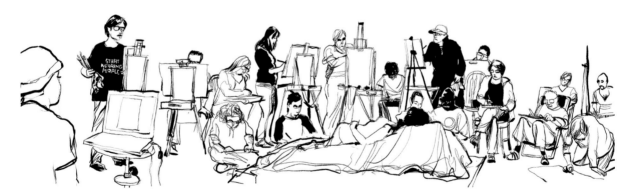

Norfolk Drawing Group by Walt Taylor (Digital sketch using Corel Painter); Walt draws people wonderfully. He not only sketches all the people in his life class, he also does it as a digital drawing.

PAPER STORAGE

334

Store paper flat in a cool, dry environment.

Store paper flat in a dark, cool environment to prevent it from warping or deteriorating. A chest with lots of large, shallow drawers is the best way to keep your drawings organized if you produce a lot. An architect's plan chest is ideal but these are huge, very heavy and expensive, and more affordable substitutes are available.

Other options for storing paper flat include a set of flat files or a portfolio.

336

Label your paper

When you cut up a whole sheet only one part of it will have a watermark. To keep track of your paper stock, label it with a light pencil annotation on the wrong side.

335

Separate paper into categories to preserve condition

Make sure your storage drawers are acid-free so that paper does not deteriorate. Line wooden drawers with acid-free material. Suggested categories for paper storage include:

- **Completed drawings**: These need to be accessible and kept in very good condition. Keep similar sizes together.

- **New archival fine-art paper**: Make sure this is buffered from the tannin in wood and in paper that is made from wood cellulose.

- **Ordinary drawing paper**: Separate from cotton rag paper if it contains wood cellulose.

- **Abrasive supports**: Some of these can be damaged by water.

- **Colored papers**: Keep colored papers out of the light to avoid changes. Some are colored using non-lightfast dye.

- **Mount board**: Avoid exposure to light and scope for uneven fading.

- **Cut mount frames**: It is often worth having frames cut in advance of use.

A specialist art paper storage unit in Green & Stone, London.

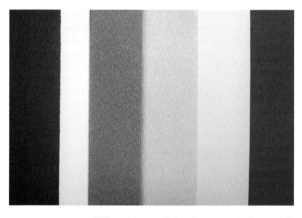

Different types of abrasive supports for pastels often come in different colors.

SKETCHBOOKS

Liz Steel fills sketchbooks faster than anybody else I know and always labels the spine and the pages at the bottom.

337

Not every page of a sketchbook has to be perfect

If you compare your sketchbook to the online versions of sketchbooks by famous painters, you will see they also made mistakes, such as skipping pages and sketching in them the wrong way up. Plus, their sketches are genuinely sketches—often just "starts" rather than mini versions of their famous paintings.

338

Try different types of sketchbook

Try different brands and formats and you will find the sketchbook that you will love for life. The key differences are size, format and type of paper (check before using wet media). Alternatively, you can get exactly what you want by making your own.

339

Try different sizes of sketchbooks

Sketchbooks vary enormously in size. My sketchbooks vary between A3 (roughly 11 x 16in.) and A6 (roughly 5 x 4in.); I use them for different types of sketching. A double-page spread in an A4 (11 x 8in.) sketchbook provides space for an 11 x 16in. sketch, whereas an A6 (roughly 5 x 4in.) sketchbook fits in a pocket.

Double-ring sketchbooks are robust but difficult to use if you want to sketch across a double-page spread.

340

Get friends to recommend sketchbooks

Ask people who work in similar media to you what they use for a sketchbook. Find out why they like it—that's really important. My personal preference is for sketchbooks that are stitchbound and lie flat when open.

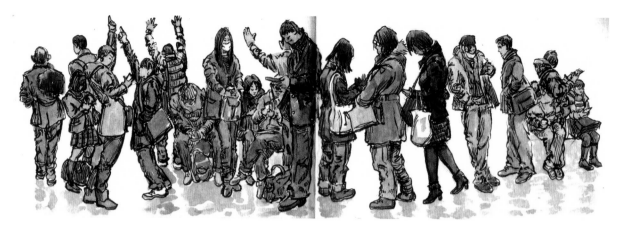

Tokyo Subway Sketch #2 by Russ Stutler (Pen, ink and watercolor wash)

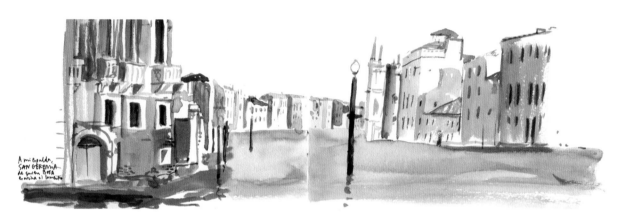

Venice—Grande Canale by Enrique Flores (Watercolor); Use of a double-page spread
in a landscape format sketchbook enables Enrique to capture the panoramic view.

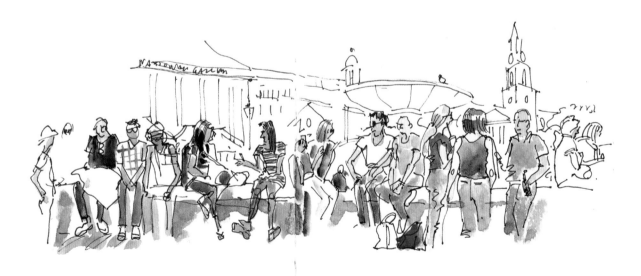

Sitting on the Fountain Wall by Lis Watkins (Pen and watercolor)

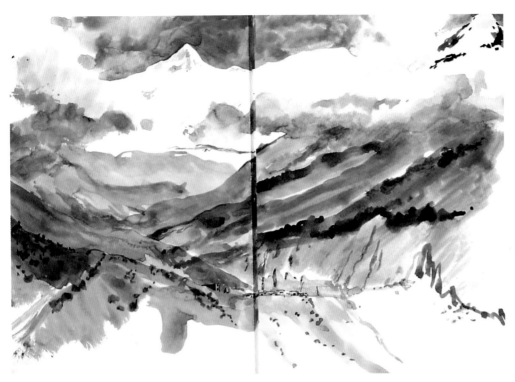

View of Annapurna II and Annapurna III, Nepal by Enrique Flores (Watercolor);
Enrique draws his travels with a paintbrush and watercolor in a sketchbook. He
contrasts big washes with calligraphic mark-making which picks out the detail.

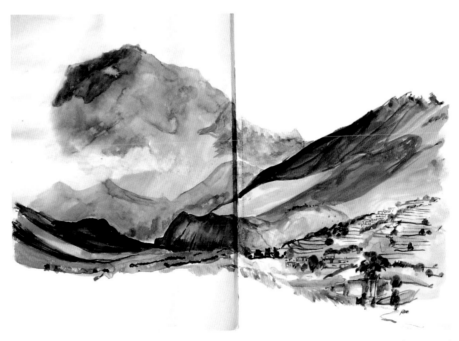

View While Trekking to a Nunnery in Nepal by Enrique Flores (Watercolor)

TOOLS FOR DRAWING

SHARPENERS

Pencils that are difficult to sharpen because, for example, the wood or pencil cores repeatedly break, are usually poor quality. The only solution is to get rid of the pencil.

341

How to sharpen a pencil

Preferences vary as to the length of the exposed core and the type of point. My personal preference is for a long and very sharp point. Tips for sharpening include:

- Inspect the sharpener. Make sure it's clean and free of debris.

- Hold the pencil in your dominant hand and the sharpener in the other.

- Insert the pencil firmly but without force. Never force a pencil to turn.

- Sharpen pencils away from a drawing.

342

Don't drop swarf or shavings

Use a brush to remove sharpening debris such as graphite swarf and wood shavings from the side and tip of the area that has been shaved. If not removed, debris can drop on the paper and create unwanted marks on drawings. Sharpeners with a shaving receptacle are essential for pencil sharpening outside the home or studio.

343

How to sharpen pastels and charcoal

Use a scalpel for sharpening in conjunction with a sanding block or "wet and dry" board. This is silicon carbide sandpaper glued to wood to provide a surface for sharpening points.

An electric pencil sharpener and the shavings from helical cutters.

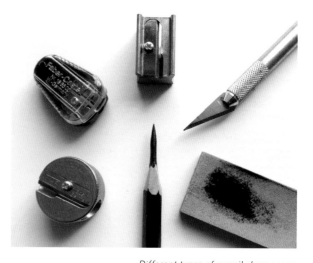

Different types of pencil sharpeners, a scalpel and a sanding block.

344

Helical blades work best

A helical (spiral) blade creates much less stress on a pencil, cuts much more efficiently and effectively and produces the very sharp points that are essential for detailed work as well as for creating optical mixes using colored pencils.

The difference a helical blade makes. Compare the points on a pencil sharpened using an ordinary handheld sharpener (left) and the point achieved when using an electric pencil sharpener with a helical blade (right).

345

Use a good-quality handheld pencil sharpener

Blades of very cheap sharpeners fast become dull and inefficient. I like sharpeners that have:

- Holes for standard and large pencils.

- Scope to unscrew and replace blades.

I'm very fond of a sharpener designed to shave the wood and sharpen the point as two separate processes.

Large hand-cranked pencil sharpeners are very popular but require a lot of effort. Use an electric sharpener to avoid RSI.

Electric sharpeners both speed up sharpening and are much valued by those who need to sharpen a lot of pencils before they start work. They are also useful for anybody who has difficulty gripping a pencil or is at risk of RSI. However, they're heavy, which limits mobility. Electric pencil sharpeners also eat graphite.

Feeding a soft graphite stick through an electric pencil sharpener helps remove residue from wood shavings, and lubricates and cleans the spiral blades as well.

SCALE DRAWING

346

Use proportional dividers to draw to scale

Proportional dividers are used to measure natural subjects such as plants, flowers and animals. They can transfer a measurement from a source to a support for drawing. You can use them to make a drawing smaller or larger than the measurement taken from the source—depending on which way round you use them.

Proportional dividers

ERASERS AND MASKING FLUID

A drafting broom

347

Learn about erasers that are kind to surfaces

Get familiar with the various types of eraser available, and choose the one that best suits the way you work.

348

Learn about erasers that change a surface

Different methods of erasing marks will have different impacts on a surface. A razor blade or very sharp knife, for example, will abrade the surface. Titanium white (in acrylic or gouache) can be used as a cover up, but be aware that most papers are not as white as this. Magic eraser sponges, when damp, work through microscopic abrasion.

349

Use a drafting broom

Erasure creates a mess and eraser residue also has a horrible habit of being incorporated into a drawing if not cleaned up. Keeping drawings free of residue is a priority.

Use a drafting broom to remove particles of eraser residue from paper and shavings from a pencil that has just been sharpened.

DIFFERENT TYPES OF ERASERS

There is a range of erasers to choose from. These include:

- **Battery-powered eraser pens**: These make erasing fast, efficient and effective. They can also be used as a drawing implement to introduce texture into a drawing.
- **Tuff Stuff**: This is a mechanical eraser. It works like a mechanical pencil: The eraser is advanced by pushing the top. It contains a core of plastic eraser and is the only eraser I know that erases marks by pastels. However, it is a lot kinder to the surface than some of the other alternatives.

- **Vinyl erasers**: These come in the form of rectangular blocks, and some manufacturers also make a propelling graphite eraser stick.
- **Kneadable putty rubbers**: These work well on fine-art paper where you want to avoid changing the surface of the paper. Kneaded dough has been used over centuries to erase charcoal.
- **Reusable putty adhesive**: Putty adhesives like Blu-Tack work pretty much like a putty rubber and can be used to lift without rubbing.

From left to right: Vinyl erasers in block and stick form; battery-powered eraser, Blu-Tack and putty rubber.

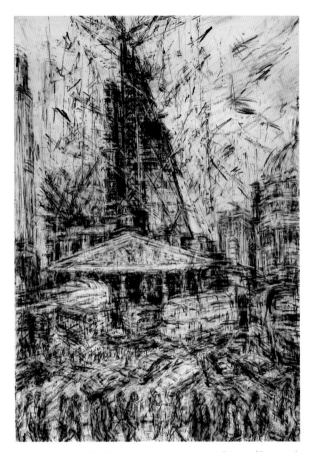

The Cheesegrater by Jeanette Barnes (Charcoal);
A drawing of buildings, traffic and people in London,
England which involves erasure of charcoal.

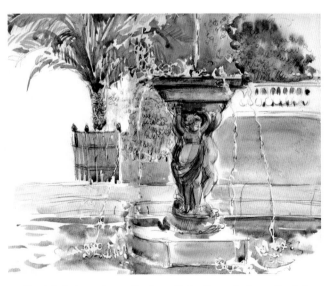

Fountain in Luxembourg Gardens, Paris, France by Laura Frankstone
(Pencil, watercolor wash and masking fluid); Masking fluid was
used in this sketch to highlight droplets of water.

350

Use a spoon to restore the surface of the paper

If paper does become abraded through erasure, use the back of a spoon to smooth the fibers out.

351

Draw with an eraser

I love to draw with a battery eraser across layers of colored pencil. Battery erasers can be used to create shapes and patterns and reveal what lies beneath (e.g., color).

352

Draw with masking fluid

Masking fluid prevents a paper from absorbing fluid media and can create marks that contrast well when using mixed media—for example, if ink or watercolor paint is applied on top. Keys to the successful use of masking fluid are:

- Think in advance about why, how and where to use it.

- Treat it as if it were opaque white paint.

- Don't use a good brush (it ruins them).

- Using a colored version enables you to see where you applied it to the paper, so you can see what you've drawn.

- Never let it bake in hot sun as this makes it impossible to remove.

BLENDING TOOLS

This section provides a brief description of a range of blending tools.

353

Control blending

Blending is such a satisfying process that it is sometimes easy to overdo it. Avoid the temptation to blend everything on the paper as it can make a drawing look very flat.

354

Explore blending tools for dry media

Use these to push dry media around the paper, soften and blur edges and blend one color into the next.

Fingers
Probably the most frequently used blending tool of all. Use wet wipes to clean up dirty hands so as to avoid transfer to media and other surfaces.

Brushes
Brushes can be used for dry media as well as wet, and are particularly effective for pushing around soft charcoal and pastel.

Paper stumps
Paper stumps are made of tightly wound paper and vary in length and width. They look like fat pencils with points at both ends. Once they've picked up dry media on the point they become drawing instruments. Clean the end by rubbing it against fine sandpaper or glass paper.

Tortillons
Tortillons are similar to paper stumps but only have a point at one end. They have a finer point and work better in smaller areas.

Torchon
Torchon is the French word for a dust cloth or wiping cloth. Put a lint-free cloth over your finger to blend larger areas.

Chamois
Chamois leather is great for blending and shading. It also has the advantage of being washable.

Paper tissues
Excellent for fast and easy blending of soft graphite or charcoal, but they do tend to crumble.

Tools used for blending (paper stumps, tortillons, blending pencil, brushes and shapers) and an indenting tool.

Grated vine charcoal dust and brush

BURNISHING TOOLS

Burnishing means to polish by rubbing and should only be done at the end of a drawing. You can polish both wax- and oil-based media. However, burnishing flattens and fills the tooth of the paper. The surface takes on a shiny, flat appearance which cannot be reversed. It is used to produce drawings of shiny or reflective surfaces.

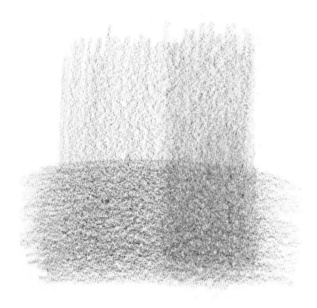

355

How to burnish

You can burnish by layering pencils. The continued pressure of pencil on previous layers helps to fill all the tooth of the paper. You can also use a blender tool. Pencil manufacturers produce colorless wax-based tools to help blend their pencils. Wax-based blenders should only be used with wax-based pencils. It is also possible to hand-burnish colored pencils.

Two colored pencils blended together with a blending pencil.

INDENTING TOOLS

Indenting is also known as impressing or incising a line.

Gayle Mason creates whiskers with an indenting tool.

356

Highlight using indenting tools

Use an indenting tool to produce a clean highlighted line with a sharp edge on robust paper. It creates a deep impression in the paper without tearing it. Develop skills in using your indenting tool before using it in a formal drawing.

357

How to create fine lines

The fine line is a negative space; the color around the indented line creates the fine line.

- Use a tool with a fine, round smooth end (such as on a ballpoint pen) rather than a sharp point that might cut the paper.

- Press the tool firmly into a sheet of smooth fine-art paper laid on a hard surface.

- Pull the tool toward you and lift off at the end if you want to produce a fine taper.

- Shade over the indentation (without pressing down) using the flat side of a soft pencil or graphite stick. The color of the paper is left untouched.

358

Create a signature

Indenting is a useful technique for creating a signature at the bottom of your art work.

STUDIO AND *PLEIN AIR* EQUIPMENT

359
Create an ergonomic layout

It is easy to develop bad habits related to layout and posture when drawing. Get your setup wrong and you'll suffer cramps and pinched nerves. Keep everything you use regularly within easy reach, don't twist to work—look straight ahead—and slant your work surface.

360
Get a good chair

A good studio chair helps to maintain good posture and minimize aches and pains. My personal preference is for a sketching chair with a back—it's more comfortable if working for long periods *en plein air*. Watch your posture if using a small sketching stool.

361
Protect your work from smudging

Protect your drawing from smudging or natural skin oils. Use a sheet of glassine, clear acetate or a smooth sheet of paper under your hand to protect your paper. A drawing bridge that fits over the artwork so your hand rests on the support not the paper is also an option.

362
Choose north light

Artists traditionally choose studios with large windows that look to the north for two reasons: north light is indirect, neutral and does not distort color, and it minimizes the movement of light and shadows on the subject matter and the artwork.

363
Work in natural light when using color

Check your color palette and artwork by taking them into natural light. Avoid intense light, such as sunlight, because it will bleach color. Work in the shade. Ordinary domestic or office lighting should also be avoided as it will distort your perception of color. Domestic lighting typically has a distinct yellow cast that distorts colors when you are working without any natural light. Use daylight bulbs in your artificial lights.

Tubular aluminum sketching chair, my pencil rolls (for travel) and a plein air sketch of the Sandia Mountains near Albuquerque, New Mexico, USA. Beware when flying; a chair like the one shown here can attract attention and additional scrutiny from airport security. It must travel in the hold so use a good-quality bungee clip.

STORAGE FOR ART MATERIALS

You will use your drawing materials much more if they are easily accessible. Dedicated storage for artists is often expensive, but you can also devise inexpensive solutions.

RECYCLE AND ADAPT TO CREATE STORAGE

- **Taboret**: This is a mobile storage container useful for storing drawing media and equipment. A dedicated artists' taboret is typically expensive. Look for equipment of similar build, such as second-hand office pods and kitchen trollies.

- **Pastel boxes**: Use plastic food boxes with lids for storing pastels used outside the studio. Fill each box with ground rice or semolina and insert pastels. Organize the boxes into color or tonal groups. This will help you transport the pastels safely, keeping them nice and clean at the same time.

- **Storage containers**: Remove any labels and reuse these for storing art materials. Possible containers include condiment glass jars with screw tops, clear plexiglass laundry boxes for bulkier items and even old tea caddies.

A pencil storage unit created by Ester Roi.

364

Create your own customized storage

Ester Roi is a professional colored-pencil artist and inventor. She made herself a set of shallow foam core drawers lined with corrugated paper. They enable clear viewing of available stock and easy access to pencils that don't roll. Step-by-step instructions on how to make the drawers are available on her website (www.esterroi.com).

You can use a lazy susan with a rotating circular base to create a holder for your colored pencils too. Instructions for how to make the pencil holder are available at makingamarkreviews. blogspot.co.uk.

Lazy susan colored pencil holder, courtesy of Lesley and David Crawford. Original design by Janie Gildow and Barbara Newton.

Felicity House's traveling pastel palettes in plastic clip boxes.

BE CONFIDENT!

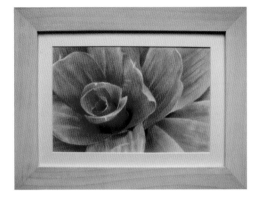

Neoregelia Scarlet Charlotte by Katherine Tyrrell
(Colored pencil)

365

Check out your confidence levels

Create your own checklist of the core drawing practices you want to become competent in. I've drafted a checklist of suggested areas you might want to be confident in and left space for you to vary it. Rate your current skills, where 1 is beginner and 5 is excellent, and prioritize your future development, where 1 is low priority and 5 is top priority. Use the blank lines to record you own particular priorities.

CONFIDENT: SEEING THE BIGGER PICTURE

CONFIDENT? ASSESS (1 TO 5)	SKILLS BASE	PRIORITY TO IMPROVE (1 TO 5)	PAGE	TIPS
	Identifying big shapes			
	Seeing positive and negative space			
	Sizing by eye			
	Assessing tonal values accurately			
	Designing and placing shapes in a drawing			
	Working from an idea to an end result			
	Working through failures			

CONFIDENT: PRESENTING YOUR DRAWINGS

CONFIDENT? ASSESS (1 TO 5)	SKILLS BASE	PRIORITY TO IMPROVE (1 TO 5)	PAGE	TIPS
	Framing your work so it looks good			
	Reflecting on and evaluating your drawings			

CONFIDENT: TECHNICAL DRAWING SKILLS

CONFIDENT? ASSESS (1 TO 5)	SKILLS BASE	PRIORITY TO IMPROVE (1 TO 5)	PAGE	TIPS
	Using preferred drawing media			
	Experimenting with new drawing media			
	Experimenting with new drawing supports			
	Drawing a line with control			
	Drawing a line with instinct			
	Drawing different shapes			
	Drawing with a good design			
	Intelligent use of color			

CONFIDENT: LEARNING MORE ABOUT DRAWING

CONFIDENT? ASSESS (1 TO 5)	KNOWLEDGE	PRIORITY TO IMPROVE (1 TO 5)	PAGE	TIPS
	Preferred subject matter			
	Reading about drawing			
	Collecting reference material			
	Read/see how past masters drew			
	Read/see new ways of drawing			

DRAWING RESOURCES

I've developed—and continue to develop—a number of websites providing resources for artists who draw. I've highlighted a few here but further details are available on my website: www.makingamark.co.uk.

DRAWING SUPPLIES

Find a list of my favorite art supply stores and read my advice about buying art and drawing materials on my website: www.makingamark.co.uk/advice-art-materials.html.

Use the Internet to check out prices, but don't forget that if you don't use your local store it might not be there in the future.

Physical art stores in California, London and Paris that I have visited, used and highly recommend include:

San Clemente Art Supply, San Clemente, California, USA
www.scartsupply.com/store

L Cornelissen & Son, London, England
www.cornelissen.com

Green & Stone of Chelsea, London, England
www.greenandstone.com

Shepherds Incorporating Falkiners Fine Art paper, London, England
www.bookbinding.co.uk

Magasin, Sennelier 3, Paris, France
www.magasinsennelier.com

Cult Pens www.cultpens.com
An online site with a comprehensive selection of pens from all over the world.

DRAWING GROUPS AROUND THE WORLD

The Campaign for Drawing
www.campaignfordrawing.org
The Campaign for Drawing is an independent charity that aims to raise the profile of drawing as a tool for thought, creativity and social and cultural engagement. Every year The Campaign for Drawing runs the world's biggest drawing festival.

The Big Draw
www.thebigdraw.org
This comprises a month of events and exhibitions about drawing across the United Kingdom and around twenty other countries with a different theme each year.

Get to know people who draw from life and sketch while out and about. Check out:

Urban Sketchers (USk)
www.urbansketchers.org

These groups are located around the world. Their blog provides links to the blogs of local USk communities around the world. Also check out the correspondents' blogs www.urbansketchers.org/p/blog-correspondents.html. Every year they have a symposium, which includes workshops at different venues around the world.

The Sketchcrawl Movement
www.sketchcrawl.com

On designated dates people around the world meet up and sketch. Check their website for the date of the next sketchcrawl.

DRAWING COMPETITIONS

There are art competitions and prizes for drawing for those who want to test their skills against the very best.

The Derwent Art Prize

www.derwent-artprize.com
For pencil artists, this demonstrates what can be achieved using only a pencil. Entry is open to international artists.

The Pastel 100 Prize

An annual competition run by the *Pastel Journal* in the USA. Entries are open to international artists but are limited to artwork that is at least 80% soft pastels.

The Jerwood Drawing Prize

Highly regarded but is only open to artists in the United Kingdom.

Strokes of Genius

www.artistsnetwork.com/competitions/strokes-of-genius
An annual drawing competition run by North Light Books. Selected entries appear in a hardback book. Eligible media are those traditionally associated with drawing.

Prince of Wales's Award for Portrait Drawing

www.therp.co.uk
Individual art societies sometimes have prizes dedicated to drawing. For example, the Royal Society of Portrait Painters awards this prize at its annual exhibition.

DRAWING CLASSES

You can find drawing classes in many locations if you know where to look. They are sometimes difficult to find, below are some suggestions of good places to look for drawing classes and workshops:

Local art schools very often run life-drawing classes in the evening and at weekends. Examples include:

The Art Students League of New York

www.theartstudentsleague.org

University of the Arts in London

www.arts.ac.uk

The Prince's Drawing School

www.princesdrawingschool.org

This venue includes courses for 10–18 year olds as well as adults.

Art museums and galleries often have an extensive program of classes—sometimes involving innovative approaches to drawing.

Art societies often run workshops during annual exhibitions. These offer opportunities to be taught by very good artists.

Individual tutors: Many tutors now use their websites or blogs to highlight their drawing classes. Sometimes you can see what they do and what their students produce. Artists in this book have a (T) for tutor after their name if they teach drawing (see page 170).

DRAWING INSTRUCTION BIBLIOGRAPHY

Many books have been published about drawing. Some of the really good ones were first published a while ago—but they are still worth consulting.

There are lots of books about drawing and sketching that I could list here. If you are interested in seeing more of my recommendations go to www.the-drawing-book.com

BEGINNERS AND INTERMEDIATE

I invariably recommend two books to beginners. They've both stood the test of time, the exercises never date and they both have many fans.

Keys to Drawing (North Light Books, 1990) by Bert Dodson

A well-structured and very accessible book suitable for beginners but also good for improvers or those needing a refresher. You will get the most benefit by doing the exercises.

Drawing on the Right Side of the Brain (Tarcher, 2012, 4th edition) by Betty Edwards

This is a bestselling book about drawing. Most people—of all ages—find it very helpful. It's now in its fourth edition and is a good read. There are more words than some might expect.

IMPROVERS AND ADVANCED

The Drawing Book (Dorling Kindersley, 2009) by Sarah Simblet

This is a book version of her lectures and teaching. It is always interesting and stimulating with wonderful images. Recommended for those keen to develop their drawing skills beyond technically correct rendering and/or those interested in drawing in art history.

Experimental Drawing (Watson Guptill, 1992) by Robert Kaupelis

Written by the professor of art at New York University, it is a brilliant and stimulating book. Originally published in 1980, it now boasts a thirtieth anniversary edition.

The Visual Language of Drawing: Lessons on the Art of Seeing (Sterling, 2012) by James L. McElhinney, et al.

This book documents the different perspectives on drawing and methodologies of fifteen current and former instructors at the Art Students League of New York. This is a "how to learn" book more than a "how to draw" book.

Drawing Ideas of the Masters (HP Books, 1981) by Frederick Malins

This book can only be purchased secondhand. This compendium of drawings by past masters provides an insight into drawing as practiced in the past. It compares and contrasts the techniques of different artists.

The Elements of Drawing (1857) by John Ruskin

This is a book that has influenced a lot of great artists, but you have to remember when he was writing it.

SKETCHING

The Art of Urban Sketching (Quarry Books, 2012) by Gabriel Campanario and the Urban Sketchers

This book kept selling out when it was first published. It showcases the work of urban sketchers around the world.

Sketch Your World (North Light Books/Apple, 2014) by James Hobbs

A helpful and easy to digest title. It's full of practical tips for those who'd like to give sketching a try.

DRAWING PEOPLE

I prefer books that focus on how past masters drew people.

Drawing Lessons From the Great Masters
(Watson Guptill, 1989) by Robert Beverly Hale

This book is one of the best investments you could ever make if you want to learn lessons from the great masters about how to draw people. I particularly like the fact he highlights why a drawing is good.

DRAWING ANIMALS AND WILDLIFE

Drawing and Painting Birds (Crowood Press, 2010) by Tim Wootton

Tim Wootton is one of the contributors to this book. This book is excellent and very practical.

DRAWING MEDIA

The Pen and Ink Book (Watson Guptill, 1999) by Jos A. Smith

This is an excellent book for those wanting to learn more about drawing in pen and ink.

COLOR

Color and Light (Andrews McMeel Publishing, 2010) by James Gurney

This is probably the best practical book about color that has ever been written. It's well informed, very accessible and very helpful. Its bestseller status reflects how well received it has been by both artists and illustrators around the world.

Color Studies (Fairchild, 2013, 3rd edition) by Edith Feisner

I'm a big fan of this book. It is great if you want to learn more about color and how it works in relation to art. It leans towards the academic but is also accessible.

CPSA's Lightfastness Test Result Workbook

Available to members of the Colored Pencil Society of America only
www.cpsa.org/cp-product-info/35-cpsa-organization/about-cpsa/101-cpsas-lightfastness-test-result-workbook.

COMPOSITION

Mastering Composition (North Light Books, 2007) by Ian Roberts

This is an excellent book for all those who want to learn more about helpful principles and techniques for composition and design. It's all about understanding the structure and dynamics of the picture plane and planning your artwork.

The Simple Secret to Better Painting
(North Light Books, 2003) by Greg Albert

A very accessible book that explains design dynamics and how to make pictures interesting. The recommendations work just as well for those who draw and sketch.

For more books about art, see www.makingamark.co.uk/art-books.html

CONTRIBUTOR INDEX

My appreciation and thanks to the fifty-five artists and illustrators who generously contributed images to this book. In particular, Chrys Allen, Mat Barber Kennedy, Jeanette Barnes, Vivien Blackburn, Nicole Caulfield, Liz Charsley-Jory, Alan Coulson, Enrique Flores, Laura Frankstone, Sarah Gillespie, James Hobbs, Felicity House, Andrea Joseph, Gayle Mason, Loriann Signori, John Smolko, Sally Strand, Russ Stutler, Walt Taylor, Lis Watkins, Liz Steel and Tim Wootton.

You can see more of their work on the website or blog listed after their name.

Artists who work as tutors and/or run workshops have a (T) after their name. Check out their websites for further details.

AUSTRALIA
Liz Steel (T)
www.lizsteel.com

CANADA
Alyson Champ (T)
www.alysonchamp.com

IRELAND
Shevaun Doherty
botanicalsketches.blogspot.com

Julie Douglas (T)
www.juliedouglas.co.uk

ISRAEL
Reuven Dattner
www.flickr.com/
photos/48041997@N04

ITALY
Federico Gemma
www.federicogemma.it/
federicogemma.blogspot.com

Ilaria Rosselli del Turco (T)
www.ilardt.com

JAPAN
Russell Stutler
www.stutler.cc

NETHERLANDS
Sigrid Frensen (T)
www.sigridfrensen.com

NEW ZEALAND
Sue Wickison
www.suewickison.com

SINGAPORE
Teoh Yi Chie
www.parkablogs.com

SPAIN
Enrique Flores
www.4ojos.com

TAIWAN
Jhih-Ren Shih
www.flickr.com/photos/lion_ren

TURKEY
Isik Güner (T)
www.isik.guner.com

UNITED KINGDOM
Adebanji Alade (T)
www.adebanjialade.co.uk

Chrys Allen (T)
www.chrysallen.co.uk
(Photography by John Whitfield
www.johnwhitfieldphotography.
com)

Jeanette Barnes (T)
www.jeanettebarnesart.com
(Photography by Chris Dorley
Brown)

Vivien Blackburn (T)
www.vivienblackburn.com

Liz Charsley-Jory (T)
www.lizcharsley-jory.com

Alan Coulson (T)
www.alancoulson.com

Susan Christopher-Coulson (T)
www.floraleyes.co.uk

Thomas Corrie
www.flickr.com/photos/
thomascorrie

Lesley Crawford (T)
www.gaia-art.co.uk

Malcolm Cudmore (T)
www.malcolm-cudmore.com

Sarah Gillespie
www.sarahgillespie.co.uk

Coral Guest
www.coralguest.com

James Hobbs
www.james-hobbs.co.uk

Felicity House (T)
www.felicityhouse.eu

Andrea Joseph (T)
andreajoseph24.blogspot.co.uk

Gayle Mason (T)
www.gaylemasonfineart.com

Harriet Mead (T)
www.harrietmead.co.uk

Sarah Morrish (T)
www.natures-details.com

Lucy T Smith (T)
www.lucytsmith.com

Ann Swan (T)
www.annswan.co.uk

Sharon Tingey (T)
www.sharontingey.com

Lis Watkins
lineandwash.blogspot.co.uk

Alan Woollett (T)

Tim Wootton
www.tim-wootton.blogspot.co.uk

USA
Barbara Benedetti Newton (T)
www.barbaranewton.net

Nicole Caulfield (T)
www.nicolecaulfieldfineart.com

Elizabeth Floyd (T)
www.elizabethfloyd.com

Laura Frankstone
www.laurelines.com

Kathy Howard
www.kathyhowardfineart.com

Mat Barber Kennedy (T)
www.matbarberkennedy.com

Jennifer Lawson
jenniferlawson.blogspot.com

Shirley Levine
www.paperandthreads.com

Paula Pertile
www.paulapertile.com

Ester Roi (T)
www.esterroi.com

Pete Scully
petescully.com

Loriann Signori (T)
loriannsignori.com

John Smolko (T)
www.smolkoart.com

Maggie Stiefvater
maggiestiefvater.com

Sally Strand (T)
www.sallystrand.com

Walt Taylor
www.crackskullbob.com

Melissa B. Tubbs
melissabtubbs.blogspot.com

COMPANIES
The Color Wheel Company
www.colorwheelco.com

CREDITS
I'd particularly like to highlight the artists who contributed to specific tips and/or checked tips in specific sections, namely:

Gayle Mason (pp. 88–91)

Liz Steel (p. 107)

Tim Wootton (pp. 91–92)

Botanical artist members
(pp. 94–97)
The Society of Botanical Artists
www.soc-botanical-artists.org

The Botanical Art and Artists Group on Facebook
www.facebook.com/groups/botanicalartists

GLOSSARY

This glossary indicates the main pages where you can find more information on the topic.

Aerial perspective (p. 32) The atmosphere typically makes distant objects appear lighter and bluer.

Analogous colors (p. 48) Hues that are adjacent on the color wheel.

Aspect ratio (p. 54) The relationship between the height and width of a drawing.

Backlighting (p. 38) The subject is lit from behind. This reduces detail and tonal range. The contour rim is often highlighted.

Blind contour drawing (p. 19) Drawing a contour looking only at the object and not at the paper. Used to develop hand–eye coordination.

Bracelet hatching (p. 35) Parallel hatching lines that follow form (e.g., of a human body). Used a lot in classical drawing.

Carbon (p. 126) This is a dry art pencil/stick medium that produces a very dense black.

Charcoal (p. 136) A popular dry art medium in stick or pencil form made from carbonized wood.

Color (pp. 46–48) One of the key elements of art.

Colored pencils (pp. 128–131) A core rod of pigment combined with a wax- or oil-based binder encased inside a wood sleeve.

Composition (pp. 52–65) How the elements of drawing are arranged according to specific principles of art and design.

Complementary colors (art media) (p. 48) Two hues that are opposites on the color wheel. Use of a complementary color darkens the opposite hue.

Contour (p. 36) This is the line that represents the edge of the form of an object(s) when seen from a particular point.

Copying (p. 69) A traditional educational exercise used to learn from the Masters. Typically involves copying their drawings, paintings or cast sculpture.

Digital drawing (p. 144) The use of software and a screen-based device to create a drawing.

Draw Making marks on a surface using tools that create shapes, forms, lines etc.

Drawing from life Observing and drawing a 3-D object or subject from reality (not from a photo of the subject). See also Techniques for drawing from life (pp. 18–23).

Drawing media (pp. 124–155) Drawings can use a wide range of media, dry and wet. However, drawings can also mix and use a variety of media (pp. 146–147).

Drawing practice (pp. 68–69) Specific focused approaches to drawing, often associated with personal development.

Drawing tools (pp. 156–161) Tools and equipment that aid different drawing processes.

Edge (p. 36) This is the line where two planes meet. Hard edges are precise and clear. Soft edges are diffuse.

Elements of art (p. 22) The defined visual components of a work of art. They are: Shape, form and volume (p. 28); Space (p. 30); line (p. 34); value, or tone (pp. 38–43); color (pp. 44–48); and texture (p. 49).

Form (p. 28) This is an element of art and design. It refers to the visible shape in 3-D.

Format (p. 54) This is the shape chosen for a drawing.

Golden ratio (p. 56) A classic guide to composition based on mathematical relationships found in nature. It's often used to divide up the picture plane. A shorthand version is the "rule of thirds."

Graphite (p. 124) A form of carbon found in rocks; used in different degrees of hardness for drawing materials.

Grayscale (p. 40) The range of different tones or values between the two extremes of light (white) and dark (black).

Hatch (p. 35) Shade using close parallel lines to produce hatching. (For examples see p. 25.)

Heighten Use of a light or white medium to indicate highlights or high key areas of drawings.

Hue A pure color unmodified by tone.

Ink (p. 138) A colored fluid used for drawing with line and wash.

Key The lightness or darkness of a drawing. High key = light; Low key = dark.

Life drawing (pp. 82–84) This description usually relates to drawing the figure in the nude.

Mark-making (p. 24) The process of creating a mark (e.g., line, tone, color, shape) on a support.

Measuring (p. 26) Assessing the length and proportion according to a standard unit (which can vary).

Monochrome (p. 44) A single color used with black and white to create tints and shades.

Optical hatching (p. 129, 133) The juxtaposition of parallel lines of related colors to create more vibrant color.

Pastels (pp. 132–135) Sticks or pans of pigment combined with a binder. The ratio of binder to pigment determines hardness.

Pattern (p. 62) A distribution of marks that have a degree of order.

Pen (pp. 138–140) A device used for drawing with ink.

Pencil (pp. 124–131) A core of drawing material (e.g., graphite, charcoal, carbon, pastel, colored wax) enclosed by wood or a cylindrical case.

Perspective (p. 32) The method used to represent 3-D objects on a 2-D surface in a way that conveys accurate information about their relative position and the height, width, depth of individual objects.

Photorealistic (p. 49) Detailed visual representation that attempts to resemble a photograph.

Pictorial Expressed as a picture; pictorial space (p. 30) refers to the 2-D space used for drawing 3-D subjects.

Plane A flat surface.

Principles of design Methods used to arrange the visual elements of art to create an artwork (p. 52). Design principles include: Emphasis (p. 56); Balance and harmony (p. 58); Unity and variety (p. 60); Rhythm, repetition and pattern (p. 62); and movement (p. 63).

Proportion The relationship of one part to another; one of the principles of design (See also Measuring pp. 26–27).

Realism (p. 64) An accurate and unsentimental representation of real life.

Recession (p. 32) The illusion of depth in a picture.

Reference photographs (p. 50) Used as an aid for drawing detail.

Rendering To represent or depict reality, particularly in relation to perspective.

Saturation The intensity of a hue.

Scale Describes precisely the ratio between dimensions of a drawing and those of the object being drawn.

Scribble marks that appear to be random, disordered and chaotic. Scribbling is what children do when they start to learn to draw.

Scumble (Noun) A broken passage of color created by lightly dragging a medium across a support. (Verb) To move a medium lightly across a support such that it catches on some parts and not others.

Sepia A brown pigment used for classic crayons and ink and monochrome and classical drawings.

Shade A hue with black (or a complementary color) added to it to create a darker value.

Shadow box (p. 76) This controls how a still life is lit and the clarity of tonal values.

Shape (p. 28) An element of drawing; shape defines the height and width the outer form of something.

Size (Noun) The substance added to paper which affects how permeable it is. (Verb) To measure.

Sketch An informal preparatory drawing. Wet media (e.g., watercolor and ink) is often used for sketches.

Sketchbook (p. 153) A book of paper intended for sketching.

Stylus (p. 144) A pen-like device used to input drawings into a computer or tablet.

Style (p. 106) In drawing, this is the unique way a person chooses to make marks and draw subjects equivalent to handwriting.

Support (pp. 148–151) This is the surface on which a drawing is made. It is not always paper hence the need to use another word. "Ground" is another word used to mean support.

Tablet (pp. 144–145) A technological device that can be used for drawing with drawing software.

Thumbnail (pp. 53–54) A very small simple sketch, usually using big shapes and a few tonal values, of an intended subject of a more refined drawing, sketch or painting.

Tint (p. 46) A hue with white added to it to lighten the color.

Tone (pp. 38–42) The light value between white light and complete dark.

Tonal range (p. 40, 50) This is the complete spectrum of tonal values between white and black. The tonal range for specific media will vary according to the scope to produce "black" and "white."

Toned paper A paper that has been prepared for drawing through the application of a color or medium.

Torchon (p. 160) A wiping cloth used for blending. "Grain torchon" means paper with a rough surface in French.

Tracing To make a copy of an image—ideally to improve it prior to transfer to a support for drawing.

Value (pp. 40–42) See Tone.

Vanishing Point (p. 32) The place on the horizon where converging lines seem to meet.

Viewpoint (p. 32) The point at which judgments are made in relation to perspective.

Zones (p. 111) Zones of interest include the background, middle ground and foreground.

For more terms relating to art, I recommend the online website ArtLex: www.artlex.com.

INDEX

ACKNOWLEDGMENTS

I dedicate this book to all those who inspire, encourage and support drawing.

I've learned so much about drawing over the years from so very many people—from past masters to contemporary artists and tutors. I'm grateful to them all for their drawings and draughtsmanship, which has inspired me to try harder; and for their cogent and practical information and advice about how to develop skills in drawing and sketching.

This book would not have been finished without the help of my best friend and partner—known online as "he who must not be bored while I sketch." He takes good care of me while I take care of business. I always appreciate his invaluable and practical support and am especially thankful for all he did that allowed me to dedicate time to this book.

ABOUT THE AUTHOR

Katherine Tyrrell shares tips, reviews and resources about art nearly every day on her blog "Making A Mark," makingamark.blogspot.com.

This hugely popular and top-rated art blog (currently no. 3 in the UK, no. 9 in the world) now gets an average of around 5,000 page views each day and attracts well over half a million unique visitors each year.

She's a dedicated sketcher. Her "Travels with A Sketchbook" blog (travelsketch.blogspot.com) has featured in and been recommended by *The Times* newspaper (in London). Katherine is also a member of Urban Sketchers London (see urbansketchers-london.blogspot.co.uk).

You can view examples of some of her drawings and sketches on www.pastelsandpencils.com. This also includes details of exhibitions of her work, and her workshops and talks.

Katherine has also developed a number of popular "resources for artists" websites out of interests and blog posts that focus on drawing and dry media. You can find a compendium of these websites on www.makingmark.co.uk.